IMAGES
of America

PEEKSKILL

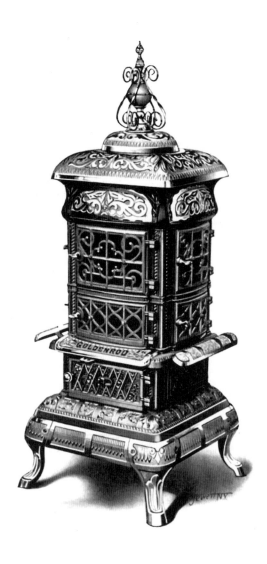

GOLDENROD PARLOR STOVE. Union Stove Works on Central Avenue produced this and numerous attractive heating and cooking stoves a century ago for local, national, and international markets. Such Peekskill industrial artisans had been unionized by 1856.

IMAGES
of America

PEEKSKILL

John J. Curran

ARCADIA

Published by Arcadia Publishing
Charleston SC, Chicago IL, Portsmouth NH, San Francisco CA

Printed in Great Britain

Library of Congress Catalog Card Number: 2005924386

For all general information contact Arcadia Publishing at:
Telephone 843-853-2070
Fax 843-853-0044
E-mail sales@arcadiapublishing.com
For customer service and orders:
Toll-Free 1-888-313-2665

Visit us on the internet at http://www.arcadiapublishing.com

CONTENTS

ACKNOWLEDGMENTS

The Peekskill Museum Board of Trustees includes the following, who approved the use of their extensive photographic archives for this project: Calvert E. Schlick Jr., Paula Bodger Connolly, Lorman Augustowski, William and Joyce Stillman, Dolores Ubben, John Beers, and Roger Sparling. Robert Boyle, research librarian at the Colin T. Naylor Jr. Archives of the Field Library, diligently applied his expertise to this work. William Stillman assisted as Peekskill Police Department historian and retired lieutenant with 33 years of service. Lorman Augustowski, president of the Peekskill Military Academy Alumni Association and a professional printer, prepared these graphics for publication. Van Cortlandtville Historical Society president Frank Goderre provided photographs from his extensive private collection and developed hundreds of black-and-white prints for the museum. John Testa contributed photographs from his family collection. Tony Seideman, Peekskill's public information officer, supplied the Beecher photographs. Former Peekskill Museum trustee Kirk Moldoff was instrumental in securing a grant that developed numerous prints from museum glass negatives. James Napier, as staff photographer for the former *Evening Star* daily newspaper, produced most of the photographs in this book. Field Library director Sibyl Canaan displayed her usual interest, editorial acumen, and cooperation, as with any project involving historic Peekskill. The Peekskill Museum provided this city historian with office space and equipment, while the city of Peekskill gave budgetary support. David Langley is acknowledged for his insistence that this project be completed.

A Note from the Mayor

I am very pleased that the Peekskill book in the Arcadia series has been realized. This gives everyone a chance to enjoy and appreciate our richly diverse culture. The wide selection of photographs reveals Peekskill's uniquely interesting history. I am also pleased that archives have been drawn from several sources, both public and private. My personal family history is well recorded on fragile one-of-a-kind antique photographs. These images speak through time from my ancestors to my children and their future children. Please enjoy this published collection, which I understand is only a small part of our community's considerable visual resources.

—John G. Testa, Mayor of Peekskill

Further Resources: The Peekskill Museum web site at www.peekskillmuseum.com and the Field Library web site at www.peekskill.com.

INTRODUCTION

A majority of the photographs reproduced here are from the Peekskill Museum, which has stored and displayed local artifacts and archives at the former Herrick estate on Union Avenue since 1946. The museum cares for 24,000 photographic negatives from its former daily newspaper, many glass negatives, dozens of 100-year-old studio portraits, hundreds of various framed photographs, several century-old albums, many stereo-cards for three-dimensional viewing, and a nice collection of tintypes, ambrotypes, and daguerreotypes that date to photography's very beginning.

A dynamic Hudson Valley industrial community, Peekskill was a vital part of these early developments. A May 12, 1842, newspaper advertisement indicates, "Daguerreotype Portraits . . . has the pleasure of announcing to the inhabitants of Peekskill and its vicinity that he is now in readiness to wait upon all who wish a correct miniatures likeness taken by the daguerreotype process," signed H. H. Corbin. A few years later came a public announcement that ambrotypes on glass were available from A. M. Armstrong on Main Street. "They do not reverse the subject like a daguerreotype, consequently they appear perfectly natural."

Peekskill's own Victor Griswold manufactured ferrotypes, which secured images onto a lacquered iron plate, often misidentified as tintypes. The principal local photographer of the late 1800s was H. Halsted Pierce, who operated from a downtown studio. Ernest Ballard then took over the dominance of this trade in 1915. A Park Street building still bears Ballard's name.

While current photography is digitally transferable to many formats and offers disposable cameras and one-hour prints, the more difficult early days of creating physical images with light and lenses as "photo-graphs," meaning "written with light," indicate the high personal value given to such objects. Many antique scenes remain precious items. Indeed, the photographs of 150 years ago were usually delicate portraits double-framed and under glass, resting inside a small, embossed, hinged brown- or black-patterned box that was bound with a delicate clasp or two.

Both publicly and privately owned photographs and graphics are assembled here to provide the widest range of available visual archival material. Informational, beautiful, curious, and inspirational, these Peekskill scenes are divided into nine chapters.

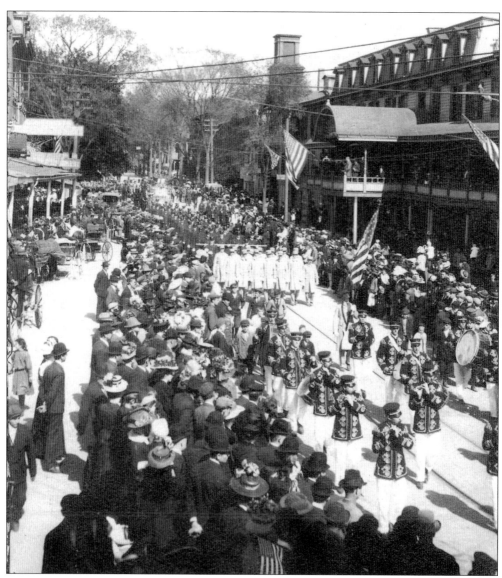

1898 FIREMEN'S PARADE. In this spectacular firemen's parade of 1898, a band and fire company pass below the Eagle Hotel balcony on Main Street. A commemorative booklet, *History of the Peekskill Fire Department, 1826–1898*, was also issued that year, indicating a long tradition of firefighter-sponsored civic parades.

One

THE EARLY DAYS

There are so many interesting ways to tell the Peekskill story.

One might relate its vital role in securing American political independence. Peekskill was the first "West Point" when it served as the Continental army's base camp for the Hudson Valley, with headquarters on Main Street in 1776 and 1777. Its small industries supplied food, clothing, and ammunition to patriot soldiers. Yet the entire Revolutionary War era seems remote because no photographic images are available from that time. Imagine how valuable a photograph of George Washington, William Heath, John Paulding, a typical Continental soldier, or the Peekskill camp would be in fixing the important people, places, and events in our minds.

The same can be said of Peekskill's namesake, Jan Peeck. No painting, photographic image, or physical description remains of this enterprising individual. Named Peek's Creek for the 1650s boatman and entrepreneur from New Amsterdam on Manhattan Island, the Peekskill locale attracted the commercial attention of other influential people.

Venerable landowner, financier, Revolutionary War militia officer, and the first New York lieutenant governor, Pierre Van Cortlandt incorporated Westchester County's first bank in downtown Peekskill in 1833. The village's leading citizens also organized the Peekskill Academy that same year. The Eagle Hotel opened on Main Street in 1835 and remained in operation under various names until 1932.

Several notable families became prominent during the early years of sloop and steamboat commerce, when small foundries also started up. The Depew and Nelson families were locally successful in business and politics, then expanded their influences to the wider country. The memory of their significance has endured in local place names and streets.

When the railroad and telegraph arrived at Peekskill in the 1840s, the community assumed even more importance as a regional center for commercial, civic, and social activities. This small energetic village on the river became attractive to leading literate people such as abolitionist minister Rev. Henry Ward Beecher, Associated Press organizer Daniel Craig, and New York City newspaper publisher Moses Beach, for whom Beach Shopping Center is named. Joseph Binney found a suitable location for his Peekskill Chemical Company at Annsville in 1864, where he generated products for national application. That small factory has since grown into the Binney and Smith Company of today, producing Crayola-brand products in Easton, Pennsylvania.

Peekskill often played a role in national events. George Washington was a frequent visitor during the Revolutionary War, Pres. Martin Van Buren was welcomed at the Eagle Hotel on Main Street in 1839, and Abraham Lincoln made a memorial stop at the village in 1861. Peekskill had clearly become a part of the progressive American scene.

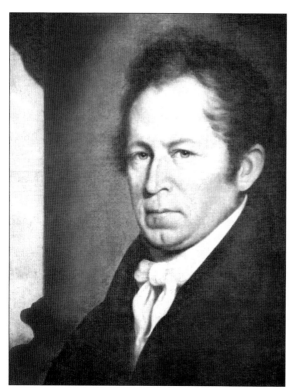

PATRIOT HERO. John Paulding assisted in capturing British conspirator Maj. John Andre at Tarrytown in 1780. Awarded a special Congressional medal and a confiscated Tory farm in nearby Crompond for his military service, Paulding frequented the Peekskill community for the rest of his life, and a street is named in his honor. New York City recognized John Paulding in 1827 with an inscribed monument at old St. Peter's Cemetery in Van Cortlandtville.

BIRDSALL HOUSE. Peekskill resident Daniel Birdsall, once attached to the 5th New York Continental Army Regiment, and his wife, Hannah Mandeville, owned and operated this modest Main Street house. It served as General Washington's home and headquarters several times during the Revolutionary War. Washington bestowed the West Point regional command to Gen. Benedict Arnold here in 1780.

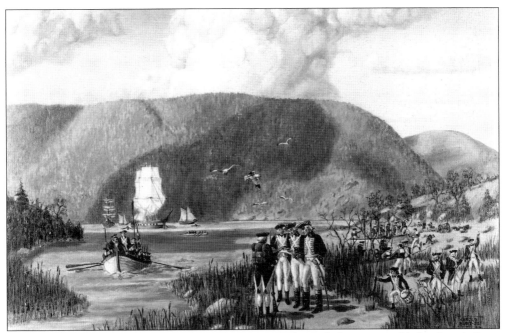

THE BRITISH ARE COMING! A powerful contingent of British forces assembled at Lent's Cove and marched into Peekskill with artillery in March 1777. The invaders confiscated and burned as much as they could of American military supplies before Colonel Willett's fierce counterattack pushed the invaders back to their waiting ships.

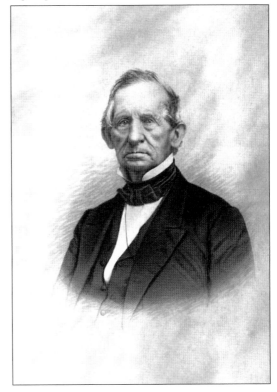

WILLIAM NELSON. This prominent Peekskill attorney was elected to the state assembly and senate, then to the U.S. Congress, where he befriended Daniel Webster, Henry Clay, and Abraham Lincoln during his two terms. As a lawyer, politician, and landowner, he was directly involved with every significant development of the Peekskill community during the first half of the 19th century. A street bears his name.

11

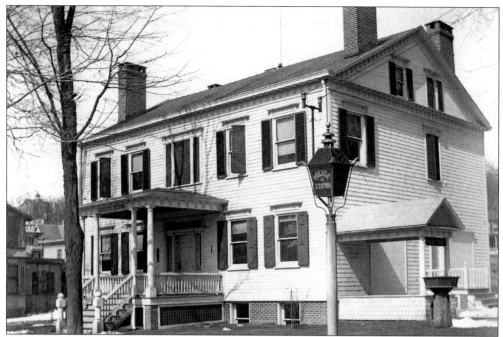

NELSON HOME ON MAIN STREET. The Nelson family donated William's fine 1820 residence to the village of Peekskill as its municipal building in 1898. The house was replaced by the current city hall building in 1937. Note the police station sign on the corner lamp. Nelson's quaint, Classical Revival law office was originally located adjacent to this residence.

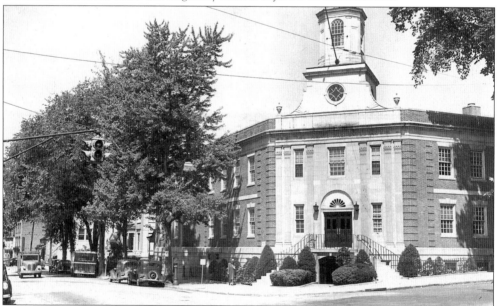

CITY HALL. Dedicated on the site of William Nelson's former residence in 1937, this edifice was designed by architect Ralph Hopkins (mayor 1942–1947). Hopkins also planned the former Masonic building on Brown Street and the original Genung's department store on North Division Street. Peekskill's transition from village to city status took place in 1940; this photograph dates to 1947.

SENATOR DEPEW. Assisted by family associations with local Congressman William Nelson and commercial leader Commodore Vanderbilt, Peekskill's own Chauncey Depew served two terms as a U.S. senator and a stint as president of the New York Central Railroad Company. He was a generous land and financial donor to the village, especially to the Peekskill Military Academy, from which he graduated.

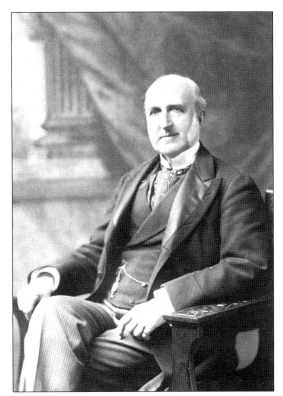

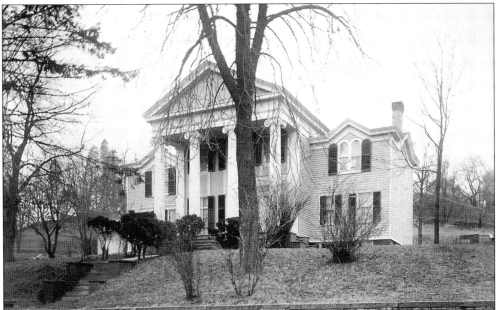

DEPEW HOME. Chauncey's father, Isaac Depew, built this enduring house overlooking the river on Main Street, an excellent example of 1830s Classical Revival in its symmetry and front colonnade. Isaac attended the Peekskill Military Academy and Yale University, later becoming a lawyer and influential politician. Isaac's father, Abraham Depew, was a distinguished veteran of the Revolutionary War.

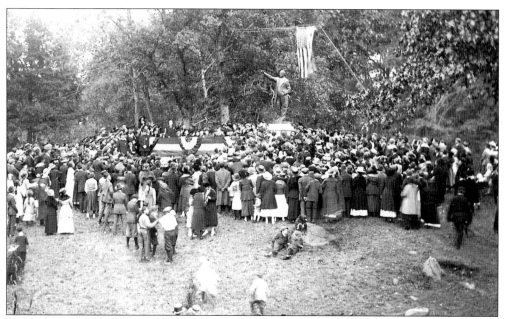

LARGER THAN LIFE SIZE. Schools closed and hundreds gathered at Depew Park to see and hear the nationally recognized personality from Peekskill as he dedicated an eight-foot-high statue of himself in September 1918. Chauncey Depew had previously been the keynote speaker at the huge Statue of Liberty Enlightening the World dedication ceremony in 1886.

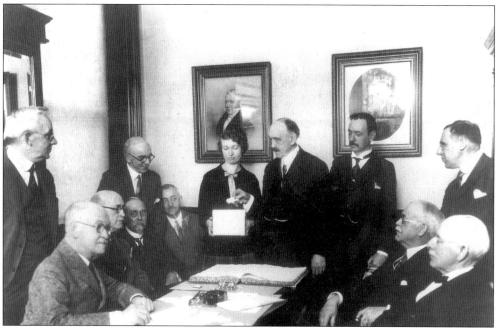

CORNELIUS PUGSLEY. One of Peekskill's most distinguished citizens, Pugsley was a U.S. congressman, president of the National Bank of Westchester, trustee of Rollins College, orator, and donor of land for the Peekskill public park that bears his name. He appears here at center among the bank's board of directors.

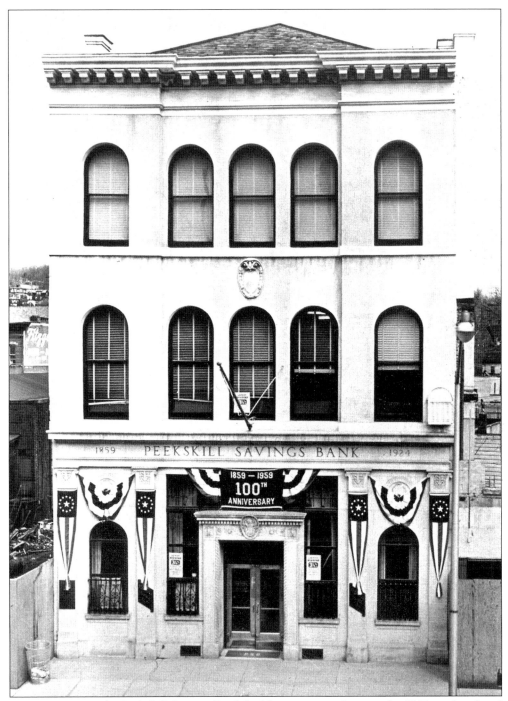

Savings Bank. The Peekskill Savings Bank building was torn down in the 1960s and replaced by the current structure. Begun in 1859, this downtown financial institution listed local industrialists Thomas Southard, Edward Wells, James Brown, and Uriah Hill as its trustees.

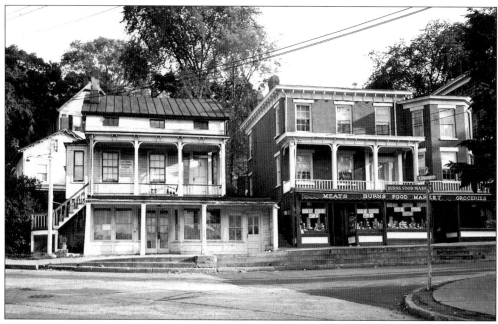

SECOND STREET. The combination of a street-level commercial storefront and family residence above was efficient in the era before automobiles. Such "mom and pop" stores were typical throughout Peekskill. The building on the left dates to the 1850s, and the one on the right to the 1860s.

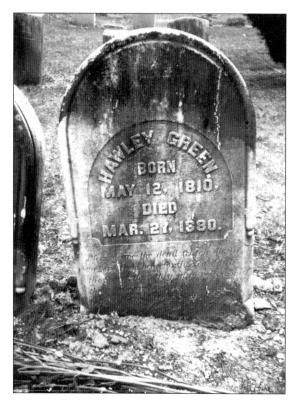

HAWLEY GREEN. This Peekskill African American businessman was a conductor with the Underground Railroad. He owned a barbershop downtown and negotiated several residential properties in the years before the Civil War, including a dwelling at 1112 Main Street. The Green family headstones are located at Hillside Cemetery in Van Cortlandtville.

REVEREND BEECHER IN PEEKSKILL. This rare scene is one of two images of a stereo view card from the 1860s. The famous orator first spoke at Peekskill in 1857, two years later purchasing a summer home and considerable acreage on East Main Street. In 1878, Beecher commissioned the existing 20-room mansion, which was remodeled in the 1920s.

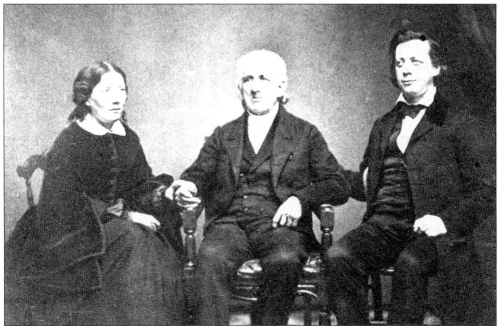

THREE FAMOUS BEECHERS. Harriet Beecher Stowe and Henry Ward Beecher pose with their father, Rev. Lyman Beecher (center). Harriet's pre–Civil War novel *Uncle Tom's Cabin* caused a national sensation. Her brother, Henry, was a radical abolitionist minister at Plymouth Church in Brooklyn, equally outspoken and active against the evils of slavery.

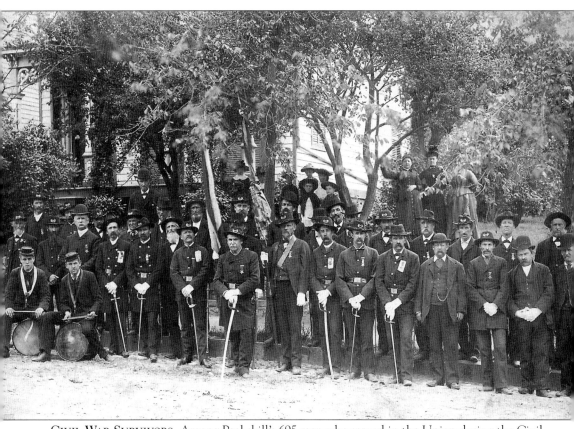

CIVIL WAR SURVIVORS. Among Peekskill's 695 men who served in the Union during the Civil War, 35 participated in a parade about 1895. Note the badge and ribbon indicating the veterans' membership in the Grand Army of the Republic organization. The several long swords held by men in the front row indicate their mounted cavalry activities.

MR. LINCOLN AT PEEKSKILL. After winning the 1860 presidential election, Abraham Lincoln traveled to his March 1861 inauguration from Springfield, Illinois, on a New York Central train through New York State. His stop at the old Peekskill railroad depot on Water Street on February 19, 1861, was the setting for a brief public statement. The president-elect spoke about the national difficulties before both him and this country.

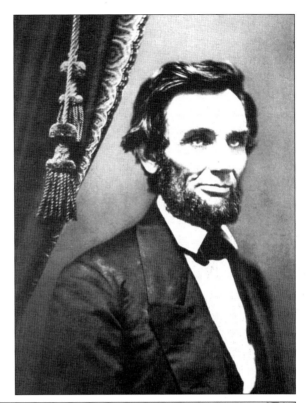

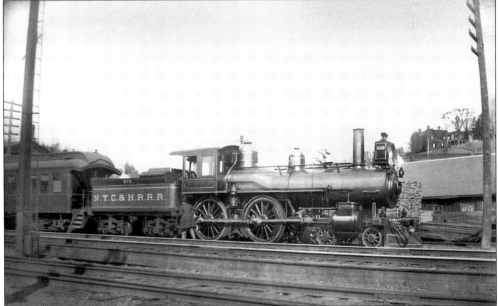

IMPRESSIVE LOCOMOTIVE. Peekskill's importance as a railroad stop is indicated by this fine example of a New York Central and Hudson River Railroad steam engine. First reaching the village in 1849, the trains competed against the steamboats for passenger and freight business. Peekskill's Chauncey Depew was the president of New York Central Railroad from 1885 to 1928.

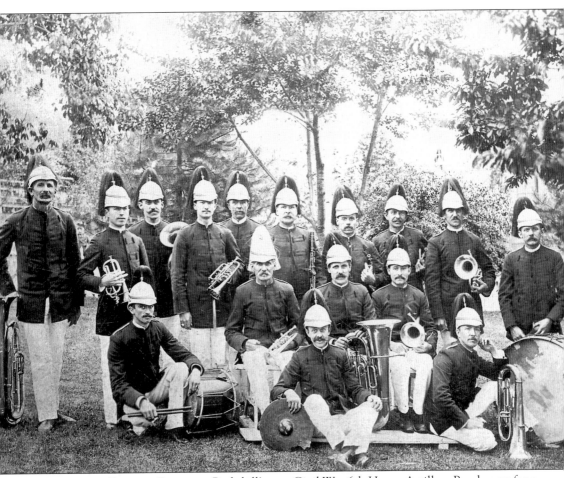

BAND WITH BROKEN CYMBALS. Peekskill's own Civil War 6th Heavy Artillery Band poses for a portrait in 1894. Thomas Flockton, seated on the left with the cornet, sounded a trumpet charge at the Battle of Antietam in 1862. Edward Depew appears kneeling at left with the snare drum, while Henry Harlan, William Hughes, William Manser, and John Boyd hold brass instruments. A Mr. Harlic was on bass drum. Sidney Smith (front row, center) holds the famous brass cymbals that were shattered in battle. These band members assembled from upper Westchester, Putnam, and Rockland Counties.

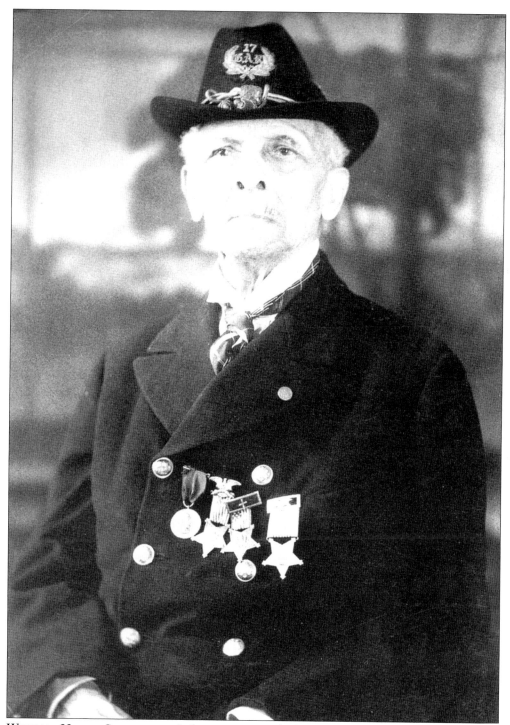

WILLIAM HENRY SINGLETON. A first sergeant with Company G of the 35th U.S. Colored Infantry during the Civil War, Singleton settled in Peekskill later in life. He also met and spoke with President Lincoln at General Burnside's headquarters in 1862. His "Recollections of My Slavery Days" was published by Peekskill's *Highland Democrat* in 1922.

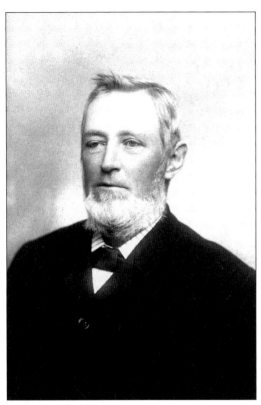

REUBEN FINCH. The Finch foundry building was located on Main Street near Southard Avenue. Finch, seen in this 1912 photo portrait, was also a founder of Union Stove Works. Many local companies incorporated their owner's names, such as Horton and Mabie, Wiley and Conklin, Taylor and Flagler, and Southard and Robertson. The first stove made at Peekskill in 1835 by Rikeman and Seymour is featured on the city's seal.

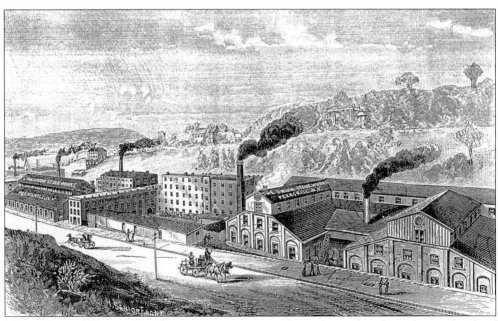

UNION STOVE WORKS. Stretching as a continuous industrial complex along the north side of Central Avenue in 1902, Union Stove Works operated from 1867 to 1932. Its notable president, Uriah Hill, gave his name to the fine 1912 Victorian-style school on Pemart Avenue. The buildings to the right remain today.

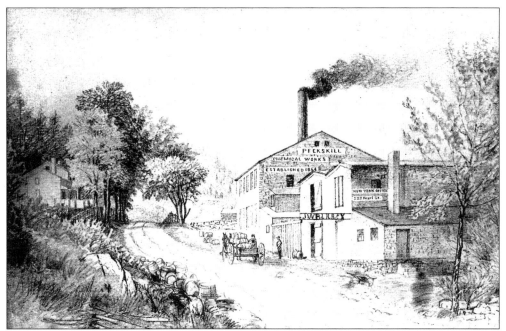

PEEKSKILL'S CRAYOLA CONNECTION. Joseph Binney lived on Main Street while his Peekskill Chemical Company operated at Annsville, innovating several useful products such as red barn paint and coal black for rubber tires. The Binney and Smith Company later produced Crayola items while based in Pennsylvania. This rendition dates to 1871.

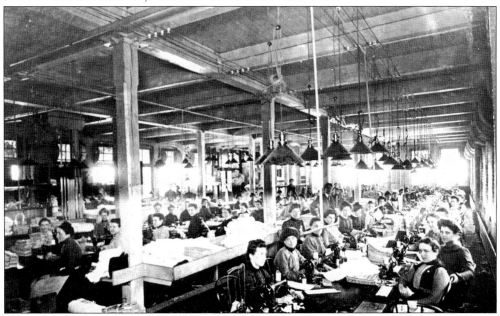

SEWING AND STITCHING. Rows of women busy with sewing machines fashioned underwear for women and children at the Baker Underwear factory on Brown Street from 1892 to 1924. John Baker lived for many years on the site, now occupied by the Peekskill Middle School. A memorial plaque indicates Baker Field in the rear of the building. He also rebuilt the Depew Opera House as the Raleigh Hotel after a devastating fire in 1900.

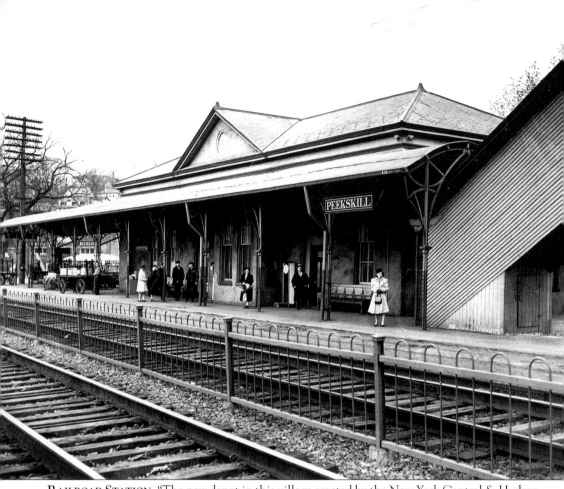

RAILROAD STATION. "The new depot in this village erected by the New York Central & Hudson River Railroad Company was opened to the public on Monday last," announced the *Highland Democrat* newspaper on May 9, 1874. The interior was finished in chestnut with black walnut trimmings. The telegraph office was also located at the new station, which is still active today.

Two

A Victorian Community

Following the personal triumphs and traumas, national victories and defeats, of the dramatic Civil War, Americans once again got down to the business of business.

Peekskill foundries expanded the markets for their finely crafted products from local to regional, national, and international outlets. Several institutions discovered the Hudson hills as ideal locations for their private facilities, religious schools, convents, and monasteries. For example, the Field Library began in a riding stable on Smith Street in 1887. Local women organized and staffed the first Peekskill hospital. St. Joseph's School at Mount St. Francis, the Mount Florence educational complex for girls, and St. Mary's School were placed at prominent locations. A New York State military training camp began at Annsville. The local police department became professionally organized in the late 1800s, and fire companies expanded and built state-of-the-art fire houses.

Peekskill industries branched into hats, shirts, and underwear. The village's numerous cast-iron foundries fabricated and marketed nickel-plated stoves, furnaces, cooking utensils, and plows. Unionized skilled artisans fashioned cooking and heating stoves for generations in this small village on Peekskill Bay.

Peekskill's industrial leaders were also its civic leaders. Plow and stove makers Southard and Roberston family members served as village presidents. Uriah Hill, Reuben Finch, Lents, and Hortons took official positions of village councils. Their homes and distinctive cemetery tombs, some cast in metal, provide constant reminders of their innovative industrial enterprises.

The population expanded as the local economy grew. A blast furnace and large wire mill operated along Annsville Creek. Necessary infrastructure improvements, such as sewers, were installed and water supply reservoirs were acquired. Telephone service and home mail deliveries began. In 1899, trolley service began, inexpensively transporting residents to their fraternal organizations and benefit societies, the center of all social life at this time.

Several villagers even became political leaders. Former resident Peter Cooper was a candidate for the presidency in 1876. Peekskill's own Chauncey Depew received nearly 100 presidential votes for nomination at the 1888 Republican Convention. Depew was elected a two-term U.S. senator in 1899, Cornelius Pugsley was elected a one-term U.S. congressman in 1901, and James W. Husted dominated Albany politics as assembly speaker.

In short, Peekskill became a quintessential Victorian community in the second half of the 1800s. Many fine homes and structures, such as the Depew Opera House in 1890, were built at this time, featuring ornate porches, decorative details, and towers that are still admired and valued.

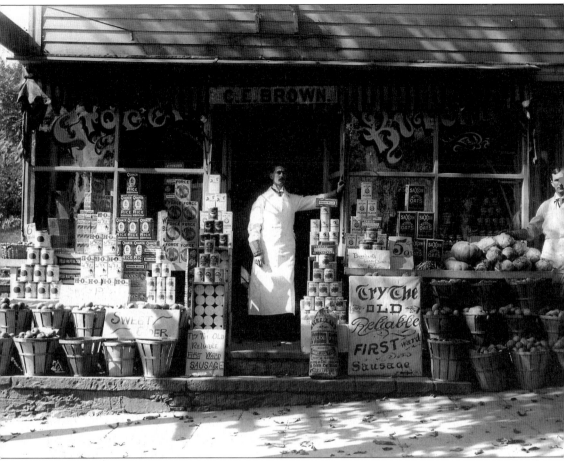

C. E. BROWN. At this store, Robert MacKellar's "smokeless fuel," crushed coke made on Central Avenue, sold for 10¢ a bag. Fresh fruits and vegetables with the latest in canned goods were available, as well as meats, as indicated by the butcher sign. The village population supported 75 similar independent groceries in 1915.

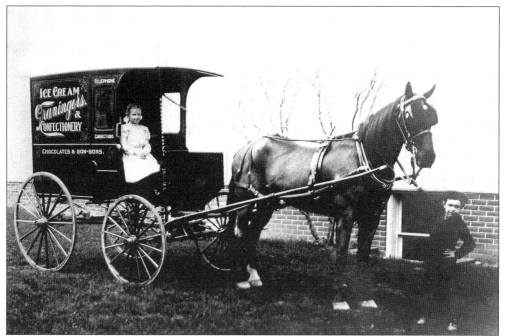

HOME DELIVERY IN 1900. An old-time Peekskill company, Graninger's, made and sold its own candies and ice cream at its 932 Main Street shop from 1890 to 1910. Toys and school supplies were also available. The Graninger's wagon would deliver goods to any part of the village.

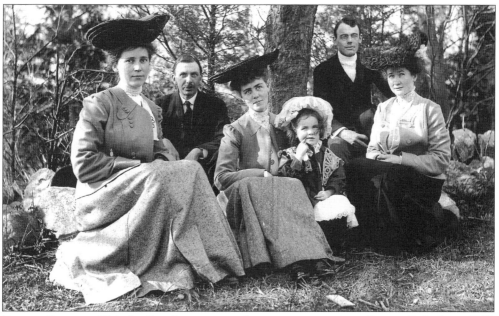

FAMILY OUTING. This family of seven poses for a group portrait in Depew Park about 1910. Their early spring clothing of high collars, jackets, and thick skirts indicates a date around Easter. We can only now imagine the relationships among these three women, one girl, and two men. Despite their admirable clarity, one of the primary difficulties with negatives on plate glass is the absence of identifications.

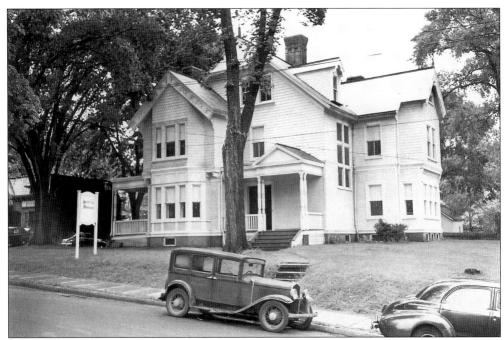

HERRICK HOUSE. The Union Avenue former home to the Herrick family has been the Peekskill Museum's repository and showplace for historical artifacts since 1946. The south-side porch and shade trees have been removed and a new paint scheme added. Financed by Herrick's father-in-law, John Simpson, architect William Rutherford Mead designed the spacious home for his former Amherst College classmate in 1877.

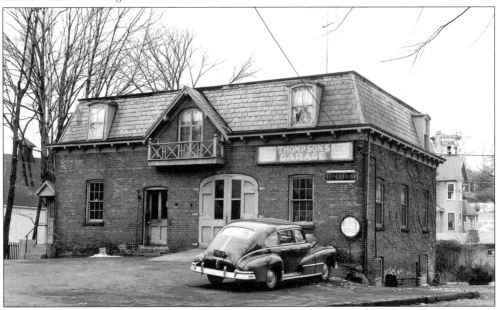

FORMER CARRIAGE HOUSE. This excellent example of a well-built carriage barn was once part of the Herrick estate on Union Avenue. After the properties were separated, Thompson's Garage was active there in the 1940s and 1950s. The building is now owned and operated by the Peekskill Knights of Columbus.

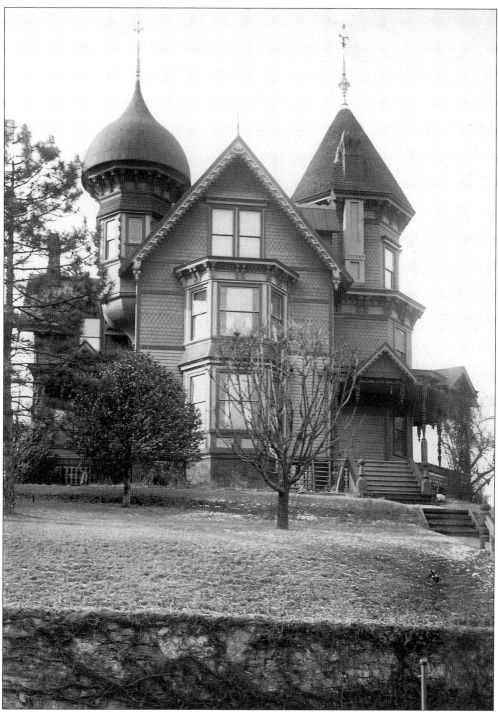

VICTORIAN FLAIR. This 138 Depew Street house was the residence of Reverend Pattison. Located on a hillside, the house included a circular onion-dome turret, a distinctive architectural element in the 1880s, matched by a six-sided tower. The structure succumbed to a devastating fire in 1950 and was removed.

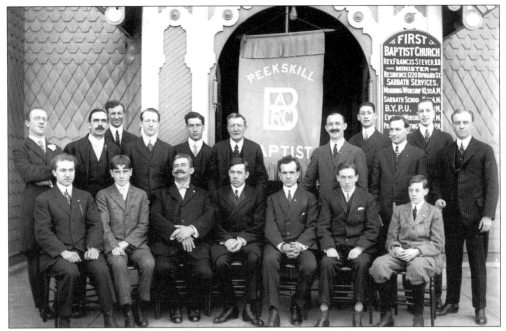

PEEKSKILL BAPTIST MEN. The ornate portico of the Baptist church, pictured here in 1915 when it was located on Main Street, reveals the male congregation in their best Sunday clothes and fine boots. The Main Street church site was purchased in 1844, and the facade revealed in this photograph was built in 1871.

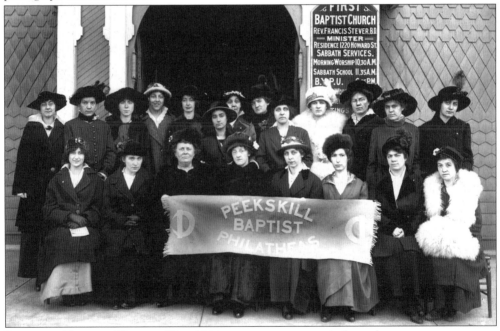

PEEKSKILL BAPTIST WOMEN. This 1915 winter group portrait shows heavy overcoats, warm hats, and a few smiles. Women of the Baptist church organized as the Ladies League in 1891 to raise money and engage in benevolent work. The congregation, organized in 1843, has since relocated to Highland Avenue.

BACKYARD TENT. These two girls seem quite comfortable in their backyard play area in 1915. A small teddy bear in a rocking chair dines at the table inside this fashionable tent. Printed from a glass-plate negative, this image boasts clarity and detail, which reveal the photographer's fine sense of composition.

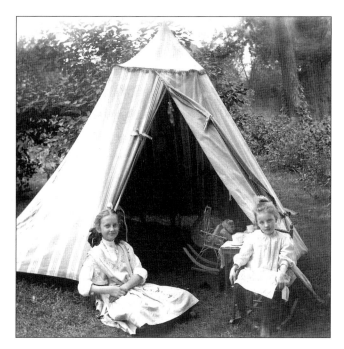

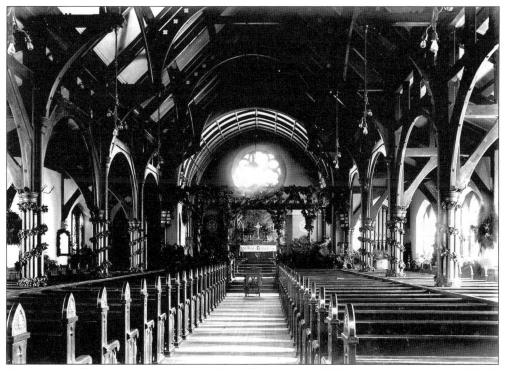

ST. PETER'S. Designed by architect Robert Upjohn, the 1905 Episcopal church on North Division Street replaced an 1838 wooden church at that location. The large interior arches create a reverential atmosphere amid exceptionally rendered stained-glass windows. The 60-foot-high stone tower houses a bell donated by the Van Cortlandt family in 1841.

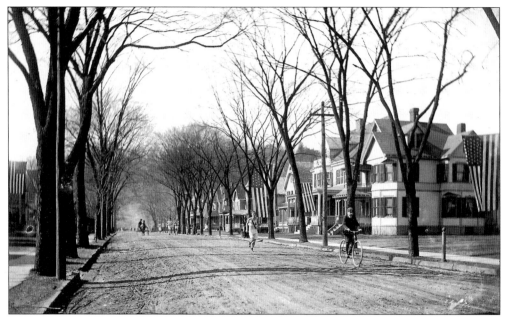

OLD-TIME ROAD RACE. Flanked by elm trees just beginning to bloom on Memorial Day in 1903, unpaved Orchard Street was an idyllic setting for this memorable road race. The boy on the lead bicycle, the large flags strung over the sidewalks, and the horse-and-buggy moving along in the distance suggest the slower pace and personal touches of the Victorian days.

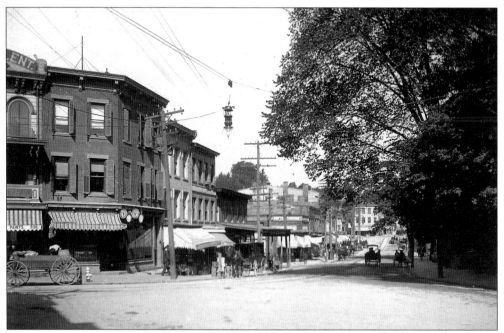

IN TRANSITION. This northward view of Division Street gives a false impression of a sleepy, placid village. Telephone poles and lines are visible along the sidewalks, and night street lighting, begun in 1900, is represented by the central hanging bulb. Trolley tracks indicate that electricity and its modern applications are welcomed and incorporated into the bustling downtown village.

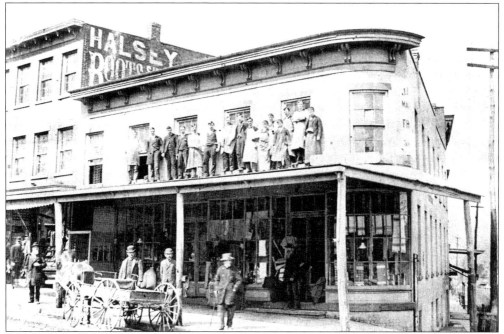

BOOTS AND SHOES. Peekskill's domestic trades are evident in this image of shoe and boot makers posing outside the second floor of a South Division Street and Central Avenue building. The unpaved roadways, horse-and-wagon, and fashions on display outside of Edwin Lent's furniture store suggest a date around 1890.

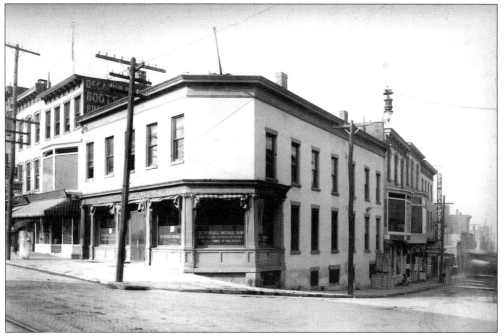

PEEKSKILL NATIONAL BANK. The Peekskill National Bank, at the corner of South Division Street and Central Avenue, was organized in 1906 with James W. Husted, John S. Baker, and Stephen Lent as founders and first trustees.

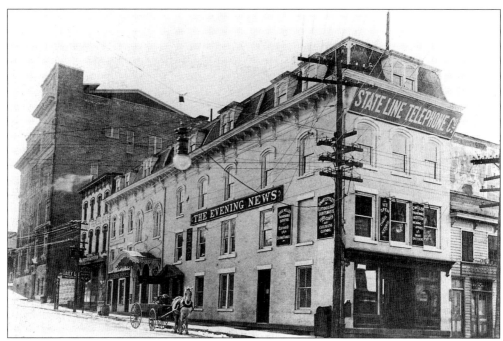

STREETLIGHT AND NO CARS. Now known as the Riley Building, this distinctive corner edifice at South and South Division Streets dates to about 1870. The State Line Telephone Company, the *Evening News*, and Weller's Clothing were the occupants around 1910. A small shop to the right was curiously named J. Ruppert.

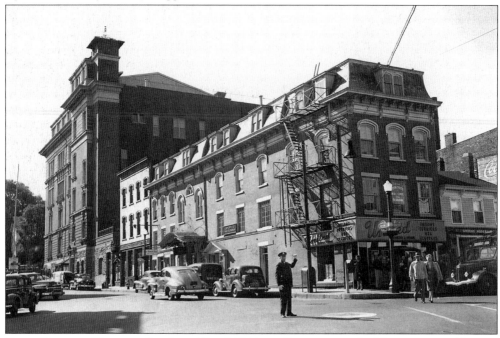

TIMES CHANGE. The same South and South Division Streets corner building is pictured here in 1947. At this time its occupants included the Thomas McPherson law office, Frank Riley Real Estate and Insurance, and a tailor and cleaning shop at the street level.

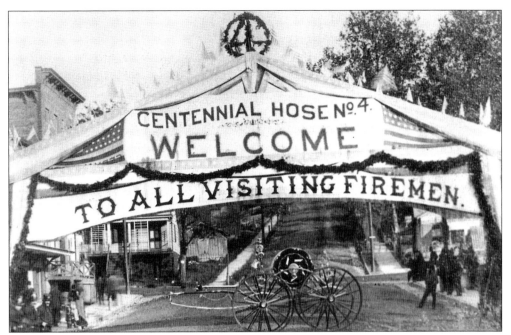

BIG WELCOME. The grand roadway arch topped with a "4" for Centennial Hose Company No. 4 appears to be located at Hudson Avenue and Water Street. The firemen's parade carriage was used as a welcome to those arriving by train. Twelve such arches were installed for the Hudson Fulton Celebration of 1909.

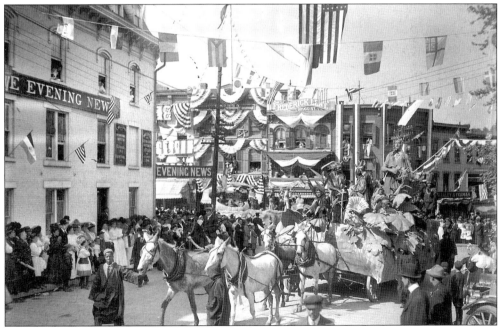

THE 1909 CELEBRATION. Two pioneers associated with the Hudson Valley, Henry Hudson and Robert Fulton, were commemorated with a state-wide, week-long series of events 300 years after the *Half Moon* passed Peekskill Bay in 1609. An elaborate float representing Native American culture was pulled by four horses at the corner of South and South Division Streets.

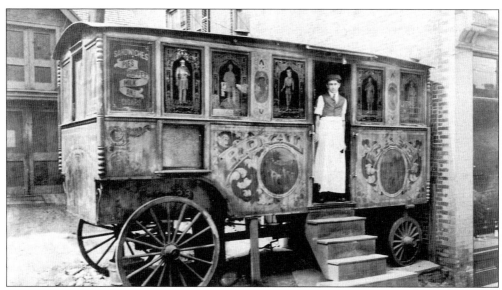

LUNCH WAGON. Fred McGee and his wife operated this painted wagon at 14 Union Avenue for many years, opening in 1907 and retiring in 1963. Named the Royal, the wagon offered sandwiches, pies, coffee, milk, and cigars. Who knew this combination would be so popular for nearly 50 years?

MAILMEN. Identified only as Peekskill mailmen, this 1900 glass-plate photograph reveals five men in a distinctive uniform. Local mail house delivery began in 1886, and these were apparently the fellows who walked door to door then.

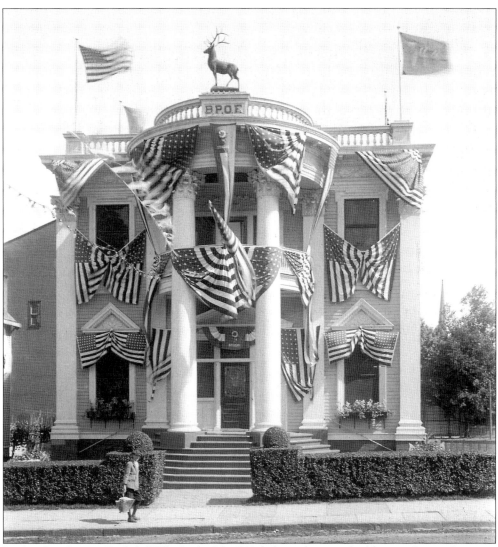

IN ALL ITS GLORY. Peekskill Elks Lodge No. 744 dedicated its new building on Brown Street on July 16, 1903. The celebration involved a fireworks display, music, flags, and bunting galore, as shown in this contemporary glass-plate photograph. A home for this benevolent organization, the hall's soaring exterior columns and rooftop elk are always a pleasure to behold.

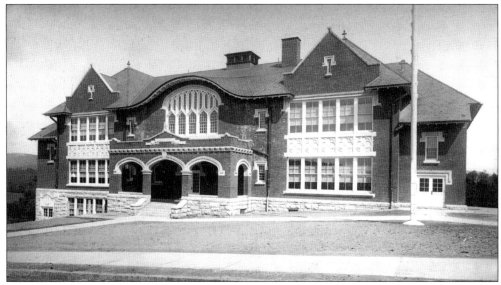

URIAH HILL SCHOOL. Resting on a granite block base, this elegant school building featured an arched portico and a multi-level roof line with a curious upper curve over a Gothic cathedral design theme. Named for Union Stove Works owner Uriah Hill Jr., this Pemart Avenue School of 1912 retains many of its original features.

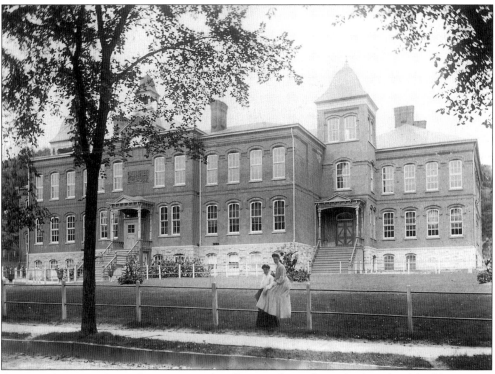

OAKSIDE SCHOOL. Once the property of William Nelson, the Oakside School building was a large brick structure completed in 1884 at a cost of $35,000. Additions were made in 1895 and 1902 as generations of local children attended classes in this memorable structure.

DR. GREEN'S HOUSE. This house was home to Dr. Charles Green, one of seven Peekskill firefighters killed during the notorious night warehouse fire at the Fleischmann factory in 1918. Green was the fire department surgeon. His home on North Division Street was an exquisite example of a flamboyant domestic style, with its turret and wraparound porch. A fire in the old house resulted in some modifications.

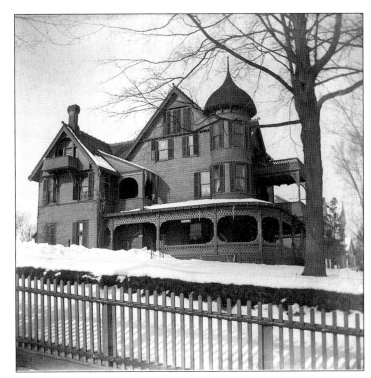

SURREY WITH A FRINGE. A surrey carriage owned by Charles Hoffman is attended to by Leo Soricelli in May 1942. The surrey was a two-seater topped by a canopy, a one-horse-powered sports model before the appearance of the automobile. Soricelli served as Peekskill postmaster for many years.

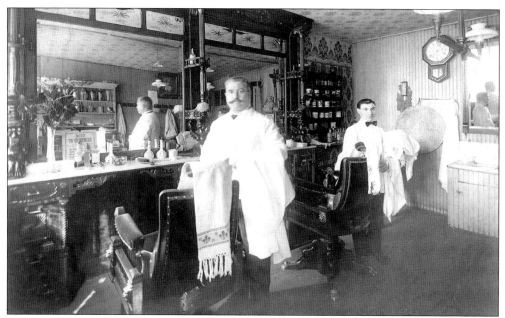

BARBERSHOP. This finely detailed 1902 view with reflecting mirrors of Joseph Testa's barbershop at 588 South Street reveals a long-lost elegance. Joseph was a founding member of the Christopher Columbus Society, while his son Louis attended the Peekskill Military Academy and worked as a clerk and interpreter for the Peekskill Post Office. Joseph's great-grandson John G. Testa became a Peekskill mayor.

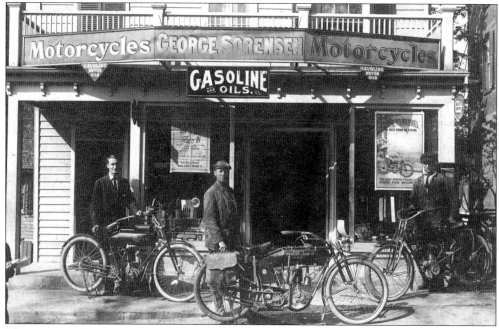

MOTORCYCLE SHOP. George Sorensen's motorcycle shop at 621 South Street featured the hardy Thor IV model. The center motorcycle sports the words "Los Angeles–New York" on its gas tank, revealing the long journey it had accomplished. "The Flying Merkel, The Next Thing to Flying" was apparently also available at this motorcycle and bicycle shop in 1915.

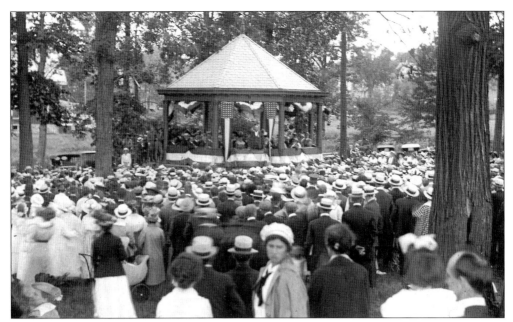

JULY 4, 1916. Noted orator and three-time presidential candidate William Jennings Bryan was the primary speaker at Peekskill's July Fourth celebration at the Depew Park bandstand. Bryan went on to become secretary of state and participate in the famous Scopes Trial in Tennessee, the basis for the 1960 movie *Inherit the Wind*. Bryan and Clarence Darrow intensely debated the issue of teaching evolution in public school.

WILLIAM JENNINGS BRYAN. The Depew Park bandstand was the setting for this close-up of Bryan's oration on July 4, 1916. The two photographs seen on this page were produced from glass-plate negatives and indicate the skilled camera work involved in providing a long shot for the scene above and a close-up view in this photograph

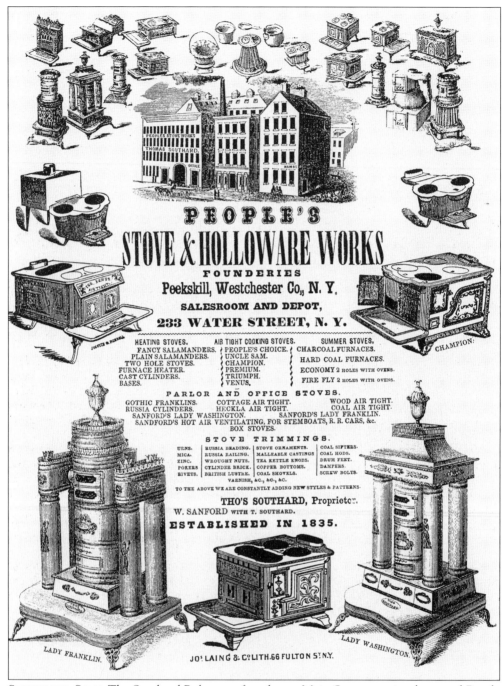

STOVES FOR SALE. The Southard-Roberston foundry on Main Street, previously named People Stove Works, was one of Peekskill's premier industries. This 1800s advertisement lists categories such as Parlor, Office, Heating, Cooking, and Summer Stoves. Trimmings available were zinc, mica, urns, pokers, railings, and ornaments. Thomas and William Southard and James and George Robertson were familiar names to Peekskill residents for a century.

Three

REMEMBERING THE 1900s

The Peekskill village population of 15,500 experienced a burst of activity in 1915 that clearly made their community a recognized center for regional business, social, and political activities. Fundamental improvements during previous decades such as dredging a channel through Peekskill Bay, securing its independent water supply, and generating its own electric power on Water Street, prompted a growth of factories and residential housing.

The 1915 directory lists these labor union organizations: bricklayers and masons, painters and decorators, carpenters and joiners, iron molders, plumbers, gas fitters and steam fitters, cigar makers, and typographers. Benefit associations were organized at Union Stove Works, the Baker Underwear factory, the Peekskill Hat factory, and the Fleischmann factory for yeast makers and distillers. Other work groups included the Retail Grocers Association, Retail Clerks Association, and Peekskill Poultry, Pigeon, and Pet Stock Association.

When the Fleischmann industrial operations were built at Charles Point in 1900, a realization of industrial continuity and employment allowed many families to financially appreciate the developing modern age. At this time, there were 13 automobile garages; 28 contractors and builders, with 5 earth and rock excavators; 21 insurance agents; 21 real estate companies; 27 lawyers; 20 physicians; 10 bakeries, and 6 newspapers.

With four moving picture theaters operating in 1915 throughout the downtown, the stage was set for the more substantial Peekskill and Paramount movie theaters to provide continuous entertainment from 1930 to the mid-1960s.

The Peekskill Highlanders was a private professional baseball team with its own stadium at Welcher Avenue and Lower South Street. That field gave way to the one-fifth-mile stock car racing track in the early 1950s. The first training camp for the newly organized New York Jets football team occurred at the Peekskill Military Academy in the mid-1960s.

A Peekskill High School graduate in the class of 1963 went on to become a city mayor, state assemblyman, and senator. George Pataki has been elected three times as New York's governor.

FLEISCHMANN OFFICE WORKERS. This rare photograph shows workers at the Peekskill plant's administrative office in the 1920s. The formal dress was likely an everyday style when the group assembled in front of the main office. Charles and Maximillian Fleischmann started their bread and brewing company in Cincinnati in the 1860s and later moved business operations to New York City.

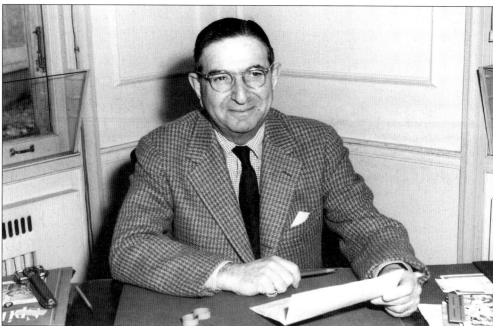

GUSTAVE FLEISCHMANN. General manager at Peekskill's Standard Brands factories since 1920, Gustave retired in 1953. The last family member involved with industrial operations, he was born in 1885 and died in 1976. He was also a founder and trustee of the St. Peter's School on East Main Street.

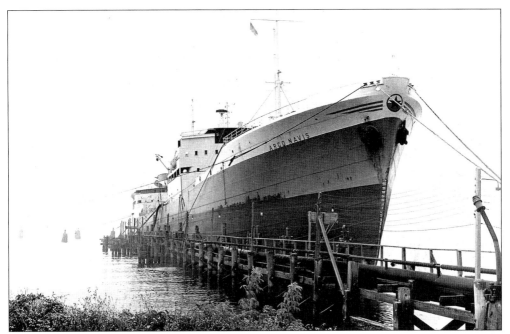

UNLOADING MOLASSES. The large ocean transport *Arco Navis* has just unloaded its freight cargo, as indicated by the high water line. The tube running along the pier from the deck to the pipes indicates liquid molasses being delivered to Fleischmann's Standard Brands Company in July 1968.

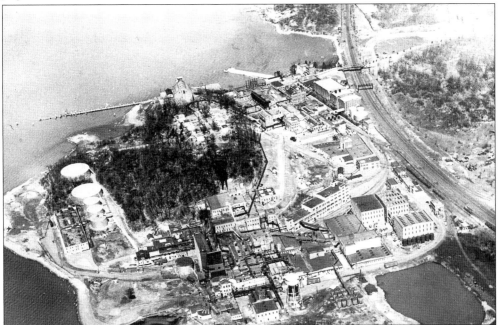

FLEISCHMANN'S FACTORY. This aerial photograph reveals the layout, size, and complexity of the yeast plant operations at Charles Point, occurring from 1900 to 1977. Since the factory was bordered by rail lines and river docks, the delivery of raw materials and transport of finished products was convenient. Worker housing was also provided on the 65-acre site.

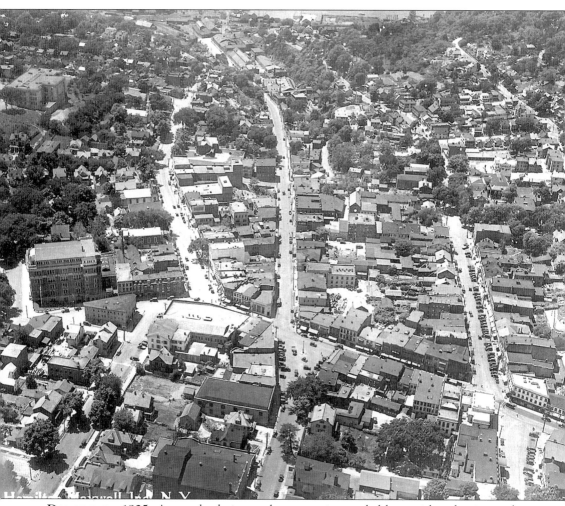

DOWNTOWN, 1925. A completely intact downtown is revealed here with a dominant cluster of commercial buildings between Main and South Streets. Union Stove Works factories are seen down Central Avenue, and the Eagle Hotel stands on Main Street where Bank Street now exists. Here, the post office is a Victorian mansion on South Street. There is as yet no Masonic Hall (1926) or Paramount Theater (1930).

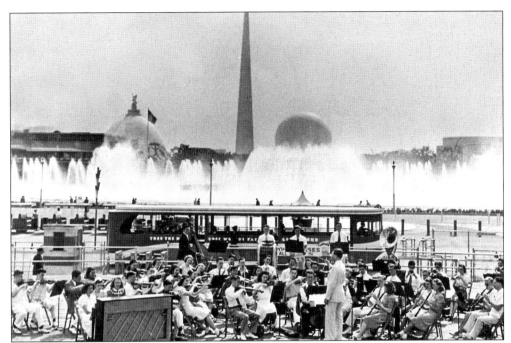

WORLD'S FAIR. Music teacher Frank Konnerth conducted the 52-member Peekskill High School orchestra at the 1939 New York World's Fair. They played the snazzy "Rhapsody in Blue" with the fair's symbolic sphere and spire appearing in the background.

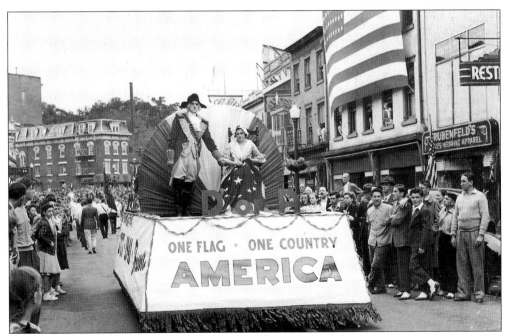

PATRIOTIC FLOAT. We are not sure if George Washington really knew Betsy Ross, but here they are together during a Division Street parade on July 4, 1941. This demonstration of patriotism was a prelude to American participation World War II, as the Japanese military would attack Hawaii on December 7th of that year.

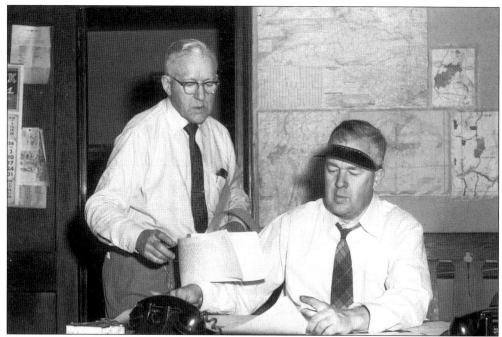

GET ME THE NEWS DESK. The *Peekskill Evening Star* was a full-sheet daily newspaper published and printed locally on Main Street for about 50 years, until the mid-1980s. In this view, brothers Donald and E. Joe Albertson check written material in their office in 1958. *Star* photographer James Napier took many of the photographs reproduced in this book.

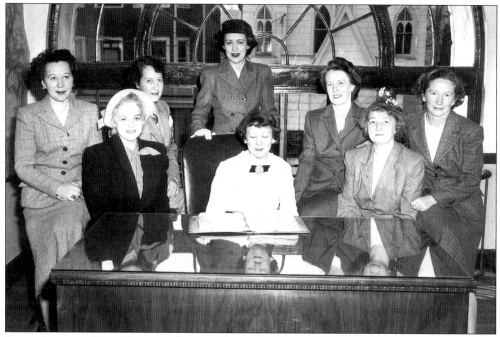

INSIDE LOOKING OUT. The upper front window in the former *Evening Star* building looks across the street to the old synagogue of 1898. Pictured around the glass-top desk in April 1949 are members of the Hospital Auxiliary Bridge Committee, who gathered for this newspaper photograph.

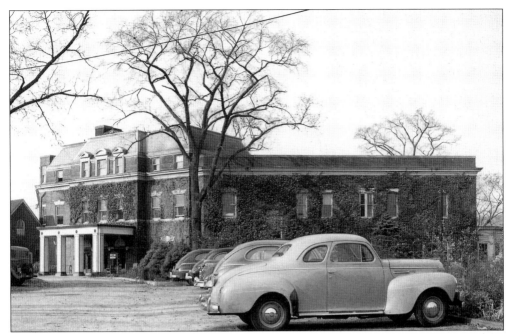

PEEKSKILL HOSPITAL. Organized by the Helping Hand Association in the late 1800s, the Frederick Requa estate on Bay Street was purchased in 1895 as a full-service hospital. Ambulance service was provided by the Montross Carriage Company, and a training school for nurses was later established.

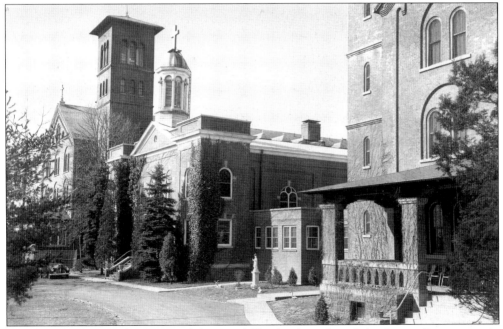

MOUNT FLORENCE. The Sisters of the Good Shepherd purchased the former Craig estate in 1875, named for Daniel Craig's daughter Florence. The Sisters educated and guided girls through high school on their extensive property between Maple Avenue and Route 202. The chapel, dormitory, and school building complex are seen here in 1952.

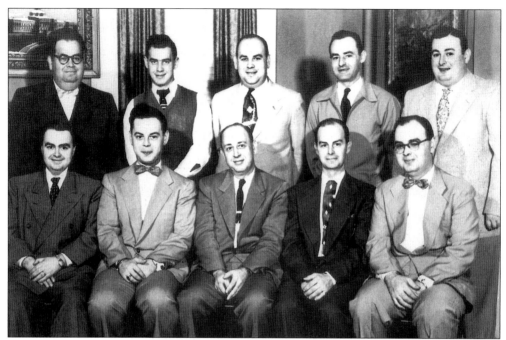

NINE BROTHERS IN THE WAR. In the Roberts family, 9 of 11 sons served in World War II. Pictured here, from left to right, are the following Roberts brothers: (first row) Leonard "Lennie" (army), James "Lefty" (air corps), John "Pete" (defense worker), Joe "Ely" (family exemption), and Stan (army); (second row) Anthony "Pants" (army), Francis "Shorty" (army), Henry "Moon" (army), Eddie (army), and Albert "Oley" (army).

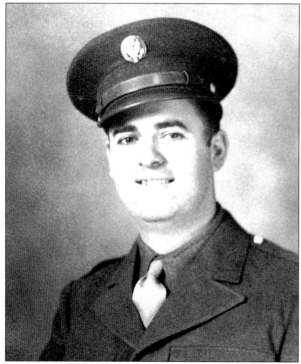

IN MEMORIAM. Charles "Runt" Roberts was a signal corps soldier killed in active service during World War II. He was the only one of the eleven Roberts brothers to die in the war.

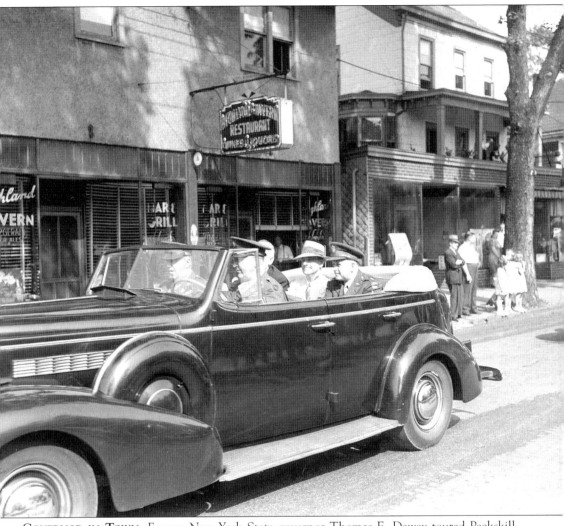

GOVERNOR IN TOWN. Former New York State governor Thomas E. Dewey toured Peekskill and inspected Camp Smith in 1943. He is seen here on Park Street with three U.S. Army officers. Dewey was a three-term governor who ran unsuccessfully against Harry Truman for the presidency in 1948.

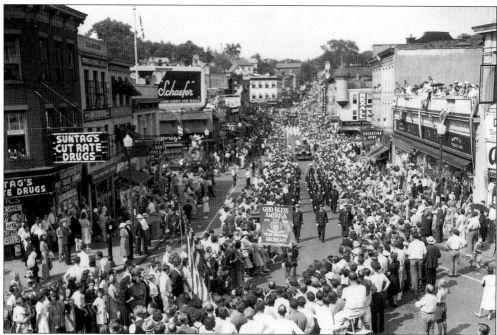

DOWNTOWN PARADE, 1948. People line the roadway along Division Street as far as the camera can reach in this 1948 scene celebrating the 100th year of the Columbian Hose Company. The post–World War II spirit is festive and patriotic, with spectators standing on the building roofs.

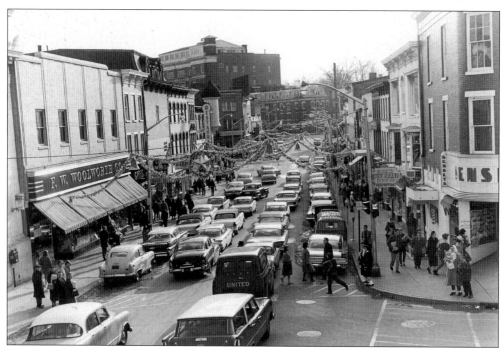

DIVISION STREET. On Christmas Eve 1960, people scurry on North Division Street for last-minute shopping as a traffic jam occurs. Along this one block, quality merchandise is available from Genung's department store, Rubenfeld's, Pisani's, Skolsky's, and Gibbs.

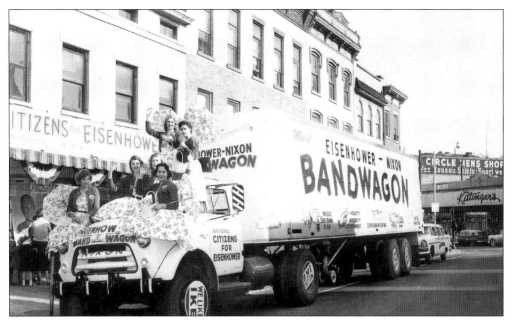

"WE LIKE IKE." Parked on South Street in October 1956, this truck cab and trailer was not exactly a bandwagon. The signs, decorations, and pretty girls represented the country at a time when the "I Like Ike" slogan was successful in winning Dwight D. Eisenhower presidential re-election. Note the Ike signs placed inside the truck wheels and the small Nixon sign on the grill, as Nixon was the vice-presidential candidate.

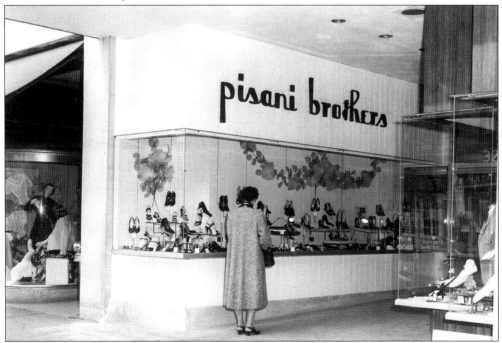

PISANI BROTHERS. The three Pisani brothers—Edward, Henry, and Dominick—operated this fine downtown store at 32 North Division Street from 1930 to 1970, selling shoes for the family and clothing for men. This photograph of their new storefront was taken in May 1954.

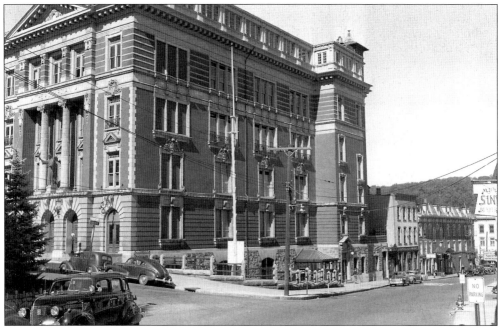

THE GUARDIAN. The large red-brick Church of the Assumption of 1905, designed by John Kerby, abounds with several traditional architectural elements. An Italian Renaissance facade appears at street level, a Roman-style second level encompasses two floors with front columns, and an imposing guardian angel statue leads to a stylized Greek temple on the front roof line.

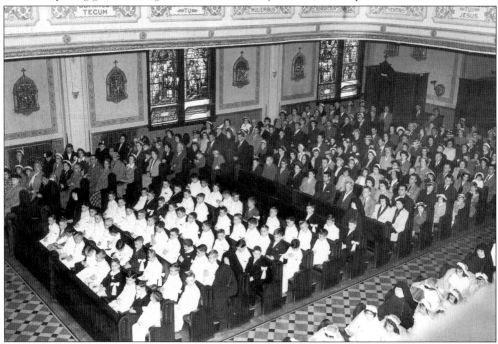

FIRST COMMUNION. Boys are on one side and girls are on the other, surrounded by their families. This photograph, taken on May 13, 1950, inside the Church of the Assumption, reveals the original building decor.

DRUM HILL STAGE. This 1941 junior high school graduation ceremony took place inside the two-story auditorium on the bowed stage, with footlights and a live pit orchestra at the ready. Drum Hill School was built as a public education palace in 1909, deliberately competing with the lavish private school buildings at St. Mary's, St. Joseph's, Mount Florence, and the Peekskill Military Academy.

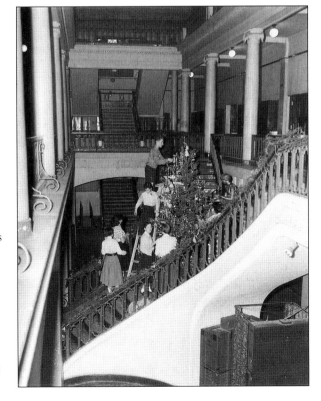

DRUM HILL ATRIUM. This school's dramatic three-floor atrium was a distinguishing feature. Its sweeping central staircase with the statue of Cleo on the landing is seen here in December 1955. Sold by the school district in the 1970s, the building has experienced three decades of neglect and abuse; although, this did not deter a recent restoration as a senior housing facility.

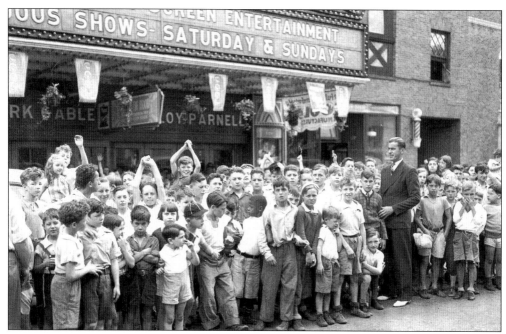

OPENING DAY. A Paramount theater opened on Brown Street in 1930. Here, manager Joe Ravese is pictured with local children. The Paramount Company was just then installing sound technology into its movie houses, and the Peekskill Paramount was among the first to be so equipped.

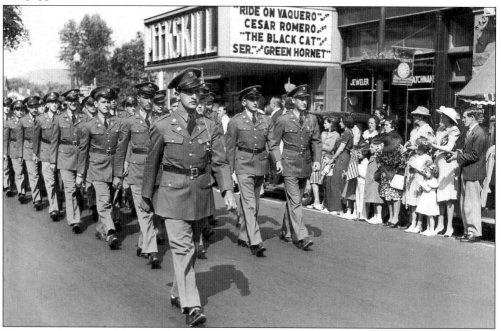

PEEKSKILL THEATER. The Peekskill Theater on South Street operated from the remnants of the former Depew Opera House. It was notable for B-grade movies such as comedies and westerns, while the Paramount Theater usually featured more expensively produced movies with big stars. This photograph was taken on Memorial Day in 1941.

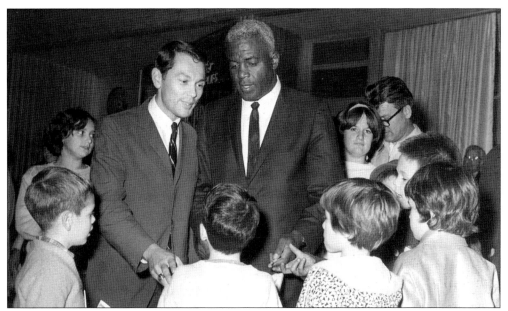

JACKIE ROBINSON AT BEACH SHOPPING CENTER. Campaigning for Republican governor Nelson Rockefeller in September 1966, Robinson was the first African American to be employed by a professional baseball team—the Brooklyn Dodgers in 1947. He served as a lieutenant in the army during World War II and retired from baseball in 1956.

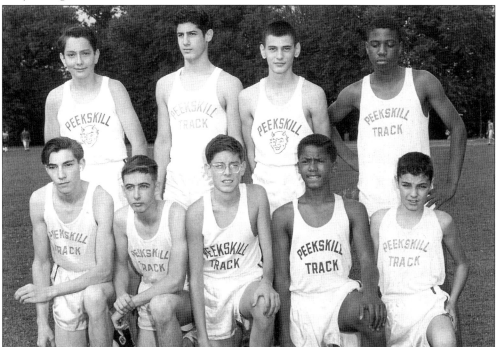

FUTURE GOVERNOR? George Pataki was a member of the 1960 Peekskill High School cross-country team. From left to right are (first row) Doug Harder, Art Rogers, future governor Pataki, future mayor Richard Jackson, and future award-winning basketball coach Lou Panzanaro; (second row) Bob Calabrese, Jeff Weiner, John Curran, and Roland Stansbury.

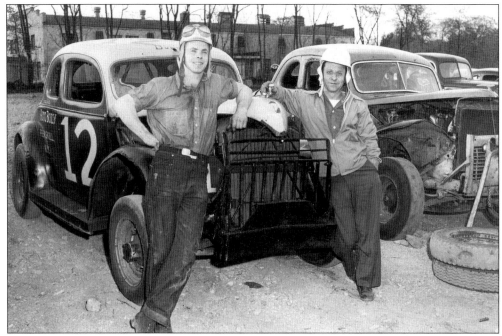

STOCK CAR RACERS. Some of the modified so-called stock or regular cars of the 1940s were raced on a one-fifth-mile track where the Welcher Avenue A&P is now located. Seen here in 1951 are driver mechanic Jack Barger (left) and driver Lenny Sabato.

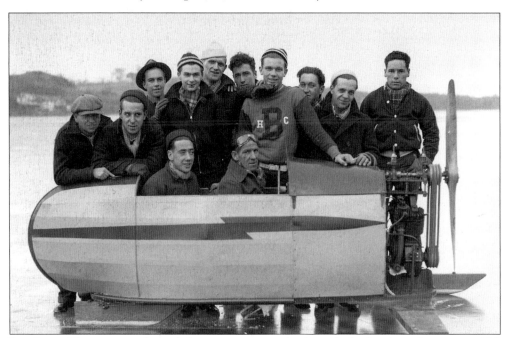

ICE SLED. This motorized ice sled was a customized job made by local mechanics in 1936. The drivers (seated) are Art Purcell and Harry Kasch. They are framed, from left to right, by Ralph Conklin, Bert Travis, Dave Miner, Clarence Napier, Hatch Pierce of Hatch's Garage on Washington Street, Roy Pritchard, Web Pierce, Tony Jenerose, Ray Travis, and Phil Bleakley.

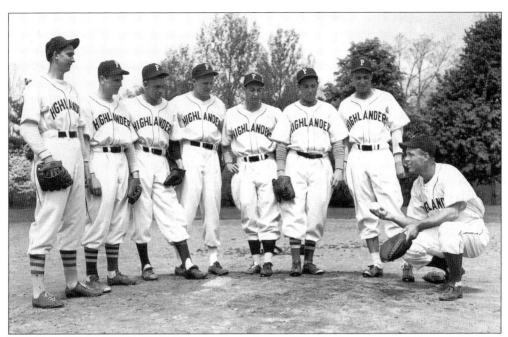

PLAY BALL. Peekskill had its own private professional baseball team from 1946 to 1949. The Highlanders became regional champions in 1946 and became affiliated with the New York Giants in the late 1940s. This portrait suggests that the player on the right was explaining the importance of keeping your eyes on the ball.

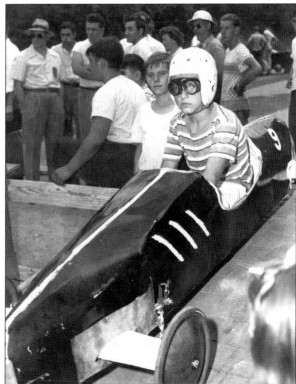

READY TO ROLL. The No. 9 car and its determined driver are about to roll down the ramp on Route 9 for the soapbox derby. The main traffic thoroughfare was blocked off for these important events in the late 1940s. Unfortunately, the driver remains unidentified.

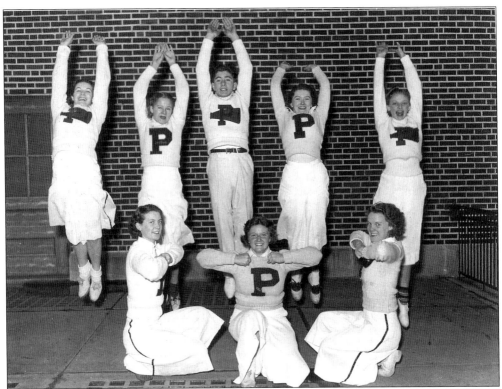

RAH RAH REE! The eight-member Peekskill High School cheerleading squad of 1937 included at least one male student. Cheerleading and marching band field routines were a steady part of school spirit at football games. The second line to this cheer was "Kick them in the knee!"

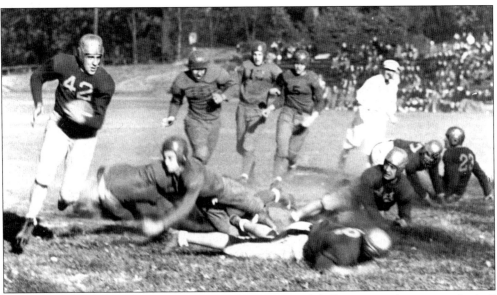

DEPEW PARK FOOTBALL. It looks like an end run as a Peekskill team member carries the ball through the Newburgh line in October 1941. Without an athletic field, the high school held its track meets and football games at Depew Park.

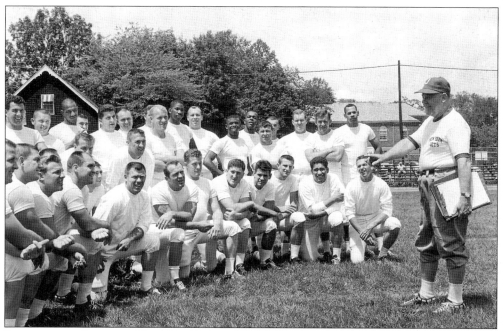

JETS ON THE GROUND. The New York Jets football team used the facilities of the Peekskill Military as its summer training camp in the years from 1963 to 1967. Club president Sonny Werblin and coach Ewbank trained their professionals off Hudson Avenue on what is now known as Torpy Field.

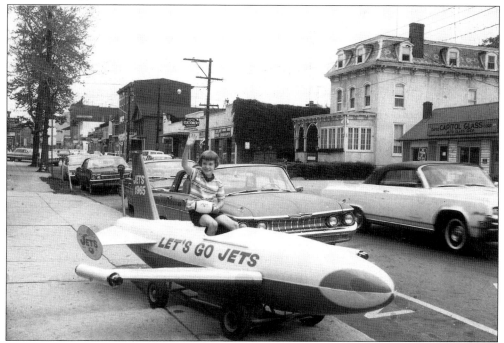

JETS CAR. Toni Strang piloted this rocket car on Main Street in 1965. The New York Jets later featured it at a Shea Stadium game promotional event. Quarterback Joe Nameth became the team's star player and was often seen around Peekskill.

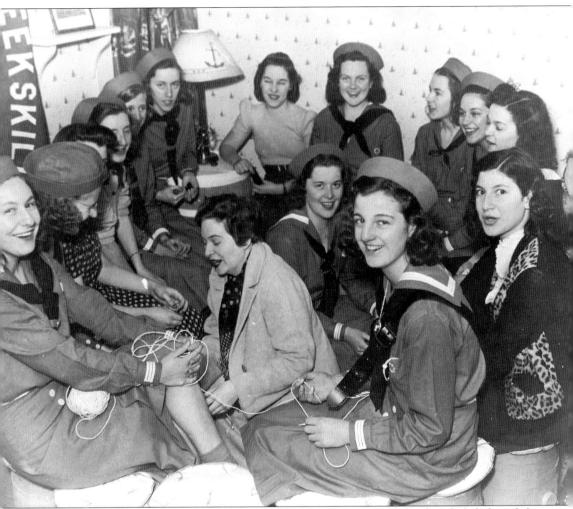

GUARDIAN MARINERS. The 1938 Sea Scouts of the Guardian School included, from left to right, Dorothy Stricker, Marjorie Shutt, Ann Hennessy, Alfreda Williams, Evelyn Nelson, Miram Doyle, Eleanor Dziadik, Madeline Finnegan, Ida Pelaccii, Grace Colangelo, Rosemary Post, and Alice Wilcox, with their leader Mary Jones.

Four

THE WATERFRONT

Peekskill's waterfront has always been the scene of action and activity—200 years ago, 100 years ago, and today.

When the single-mast sloops ruled the river waters, Caleb Hall set up Peekskill's first commercial dock and storehouse in 1745. Nearly a century later in 1833, Capt. Isaac Depew was successfully piloting his sloop *Hannah Ann*. The three docks that stretched into Peekskill Bay allowed for supplies to be delivered and products to be shipped out. Capt. Isaac Conklin owned and operated the lower dock for his own commercial purposes. One of Peekskill's principal businessmen and landowners, Nathaniel Brown controlled the center dock, where Hudson Avenue aims straight to the river. Brown was already running a tannery, sawmill, gristmill, and charcoal mill on McGregory's Brook in 1800. Capt. Joseph Travis controlled the upper dock at the north end of Water Street through the late 1700s.

New steamboat technology completely dominated the slower sail ships in the early 1800s. New names appeared on the Peekskill waterfront such as Captains Requa, Denike, and Rundle. A small iron foundry on McGregory's Brook in 1835 was a sign of similar things to come. The *Chrystenah* and *Emeline* were two well-photographed steamboats of the dozen or so that used local docks as their port.

When the first thunderous iron locomotive appeared at Peekskill in 1849, other changes evolved, evident by 1865 with most of the upper dock filled in for a lumberyard, coal yard, and small marina. Stove factories intruded themselves directly into the bay, reaching out to their water route suppliers and markets. National Stove Works, the Peekskill Manufacturing Company, Montross and Lent, and Peekskill Stove Works nudged each other at waterfront sites well into the late 1800s. Other sizable factories such as Horton and Mabie's firebrick company, the Naylor Brothers foundry, Sanford Stoves, Ely and Ramsey stove makers, Baxter Iron Works, MacKellars, and Union Stove Works took advantage of the profitable opportunities that locating on the river, Water Street, and Central Avenue then provided.

The big news on the river in the 1900s was of course the start of the huge Fleischmann's Standard Brands industrial operations at Charles Point. That company built its own existing pier into the river to accommodate mercantile ships from around the world. Charles Point is now mostly occupied by the Westchester Resource Recovery facility that incinerates Westchester County garbage and produces some electrical power in the process.

The railroad divested its waterfront property, allowing the popular Riverfront Green Park to be created in 1976.

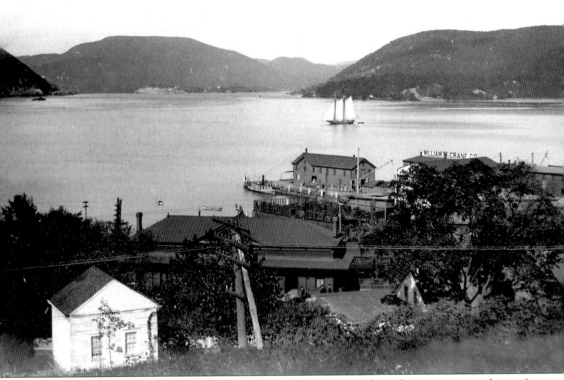

PEEKSKILL BAY. This 1900 photograph developed from a glass-plate negative makes a fine composition with flat-topped Bear Mountain in the distance and the train station in the foreground. The three-masted schooner was a familiar Peekskill sight, as it also appears on the 1911 local map. The front building at the lower dock was to service steamboat traffic. The William Crane Company manufactured the Vulcan gas range, Highland King stoves, and automobile gears from 1898 to 1910 in a building previously used by the Montross and Lent stove company.

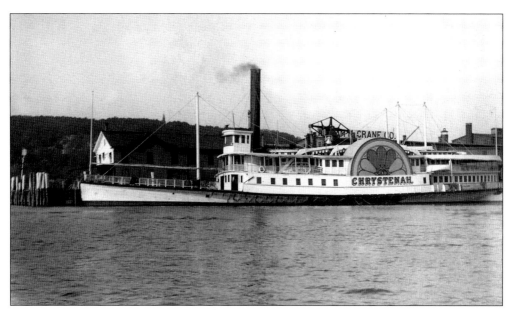

THE CHRYSTENAH AT DOCK. The popular steamboat *Chrystenah* was commissioned by Peekskill businessmen at Nyack in 1866. The river vessel was built to compete commercially with the newly arrived railroad. This boat performed well in carrying passengers between Peekskill and New York City until service was discontinued in 1904. The *Chrystenah* was named for the boat-builder's mother.

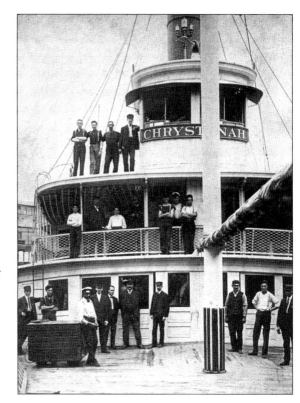

THE CHRYSTENAH CREW. This Peekskill river boat provided passenger service between Peekskill and New York City, with a one-way trip taking about three hours. Its first captain was J. Blauvelt. The North River Steamboat Company was later formed to operate the *Chrystenah* and the cargo boat *Raleigh*. A crew of 20 appears here on three levels.

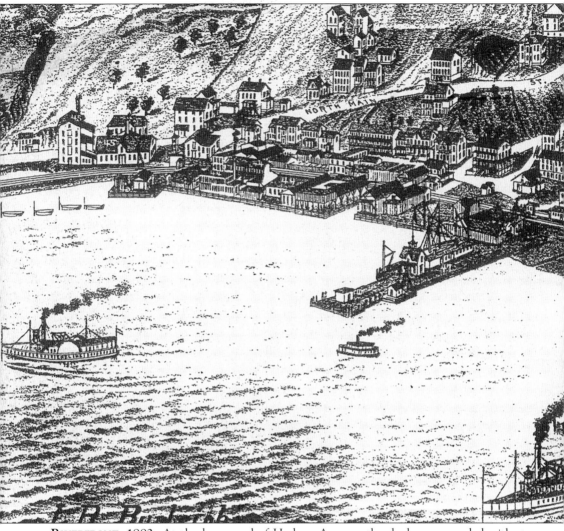

RIVERFRONT, 1883. At the lower end of Hudson Avenue, the dock was crowded with stove factories where the Riverfront Green Park now lies. Their iron slag still covers much of that shoreline. The *Chrystenah* berthed there and the smaller *Emeline* is seen chugging away at left. The center dock, at the start of Central Avenue, was operated by John Smith for his stevedore, or ship-unloading business, dealing in iron, slate, gravel, and brick. The upper dock was still

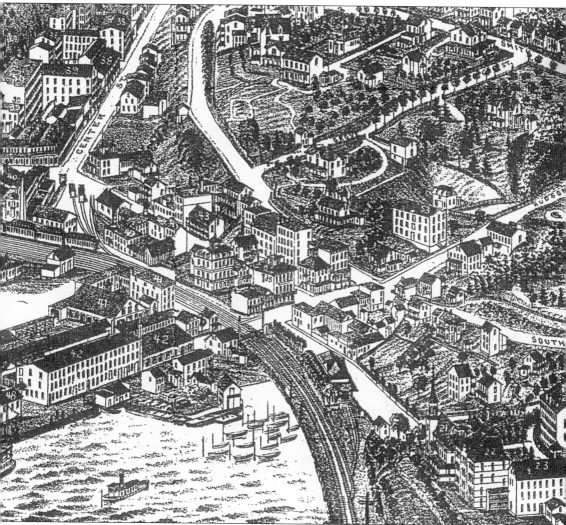

active, with the Ely and Ramsey Stove Company and the New York Emory Company nearby at the foot of Main Street. The railroad passenger station and freight depot were both in operation, and the St. Joseph's building complex operated by the Missionary Sisters of St. Frances was already well developed. The village president in 1883 was appropriately George Sanford, a stove company owner.

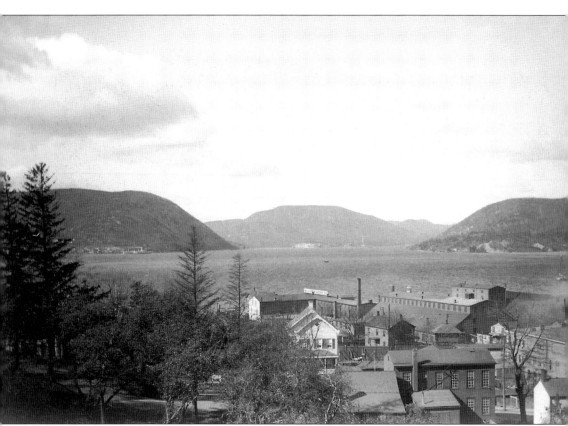

TAKING A LONG LOOK. Peekskill Bay has always offered an interesting visual experience. For more than a century, photographers have captured its many moods and stages of development from various angles. Beyond the numerous waterfront factories and toward Iona Island, a steamboat passes Caldwells' Landing at the base of Dunderburg Mountain to the left.

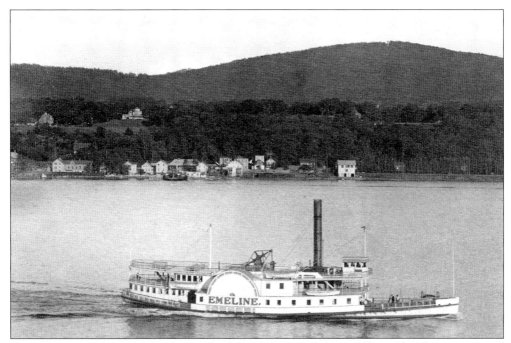

THE EMELINE. This side-wheeler was built in New York City in 1857 and briefly requisitioned for military purposes during the Civil War. After that experience and several other commercial assignments, it ran as a Hudson River steamboat from 1883 to 1916. Its main route was between Haverstraw and Newburgh, with frequent dock stops at Peekskill.

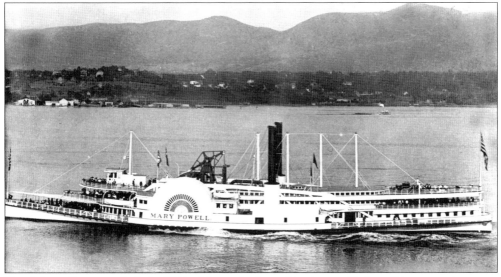

THE MARY POWELL. Built in 1861 with two boilers, this elegant Hudson River steamboat was operated by the Day Line Company until 1917, and was often seen in Peekskill waters. Such ships represented an era when the river was a dominant element to so many communities along its course.

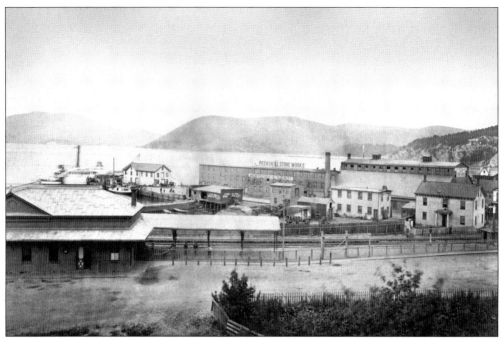

A BUSY TIME. The Peekskill Stove Works factory, formerly Montross and Lent, was located at the lower dock from 1872 to 1898. A large steamboat was docked in front of the wharf near the fine steamboat building. A much simpler building announced "Ferry to Iona" when the island was popular for excursions. The railroad station opened in 1874, and this nicely detailed photograph dates to about 1885.

SAIL RIGGING. This 1911 postcard view looks north across the deck of a sailing vessel at the lower dock. The one or more tall masts suggest these were sloops. Other Peekskill riverfront docks are seen in the background.

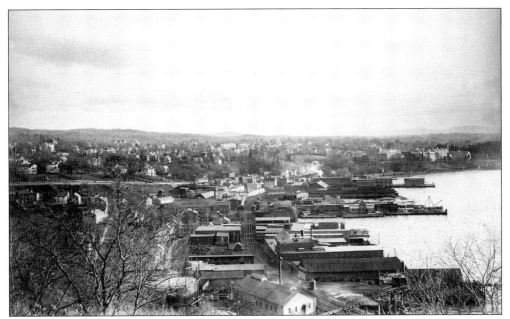

WATERFRONT COMMERCE. Factories and warehouses dominated the 1900 shoreline, their docks projecting into the bay toward the deeper dredged channel through the harbor. The railroad here cuts between the factory buildings, and Lower South Street is the roadway at mid-level.

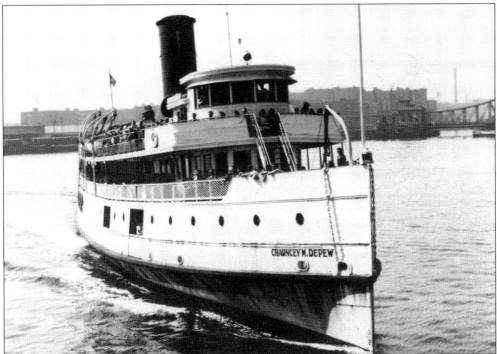

THE *CHAUNCEY DEPEW*. Named for the U.S. Senator from Peekskill, this smaller Hudson River Day Line boat was built in 1913 with a screw propeller rather than the usual side-wheel rotating paddles. It provided excursion service between New York City and Poughkeepsie before being relocated to Bermuda in 1950.

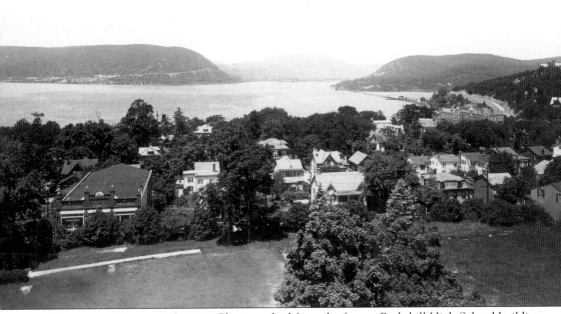

VIEW FROM RINGGOLD STREET. Photographed from the former Peekskill High School building and toward Bear Mountain, this 1950s-era scene shows the Parkway Plaza apartment building and several structures along Washington Street. Peekskill is clearly the open doorway to the Hudson highlands.

Five

THE FIELD
LIBRARY ARCHIVES

The Colin T. Naylor Jr. Archives is a special collection of the Field Library, founded in 1887 as the public library for Peekskill. Containing books, photographs, genealogical papers, newspapers, maps, scrapbooks, city directories, and audiovisual materials, this collection is named after the man responsible for preserving most of its treasures. Naylor's family donated his historical collection to the Field Library after his death in 1986 at the age of 85.

Born in Peekskill on August 13, 1900, Colin T. Naylor Jr. was a lifelong resident and a major contributor to the recording of Peekskill's history. He edited and published the *Peekskill Home News* during World War II, a monthly newspaper that detailed the experiences of local men and women in military service around the world.

In 1952, Naylor's Highland Press published *Peekskill, A Friendly Town*, authored by Chester Smith, president of the Field Library Board of Trustees for many years. Naylor wrote *Civil War Days in a Country Village* in 1961, a social, economic, and political view of the details of life in Peekskill during the Civil War years. From 1964 to 1971, Naylor worked as a writer for the *Evening Star*, Peekskill's local newspaper, where he continued as a contributor until 1980. He was also active in community affairs as a member of the Peekskill Rotary Club and the Cortlandt Hook and Ladder Company. His distinguished family had begun the Naylor Brothers Foundry and Machine Shop in 1887.

The photograph collection that Naylor's family donated to the Field Library contained over 800 original photographs. Another 20,000 such images came from the *Evening Star* newspaper archives. Naylor used many of these photographs in his later newspaper columns to highlight Peekskill's past.

The Naylor Collection at the Field Library has proved to be priceless over the years to genealogists and historians from all over the country.

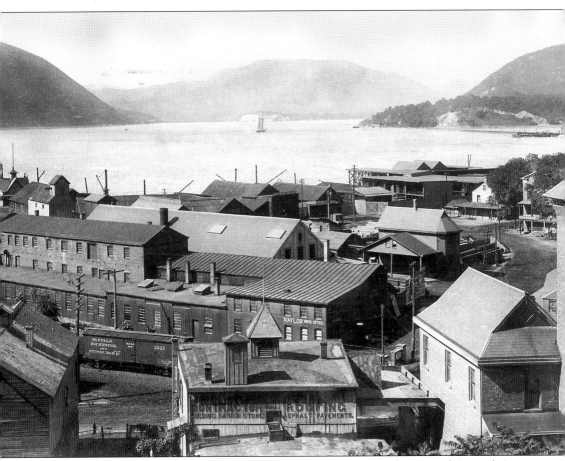

WATERFRONT INDUSTRY. Businesses along Water Street at the bottom of Central Avenue benefitted from the railroad freight station siding, convenient for supply deliveries and product shipments. The Naylor Brothers factory complex, producing industrial tools and machines, appears here at center. The original and complete Centennial fire house is at lower right, where it remained until the 1930s overpass was built. Dain's lumberyard and assorted factories occupy most riverfront property. This photograph clearly demonstrates Peekskill's participation in the industrial revolution of the late 1800s and early 1900s.

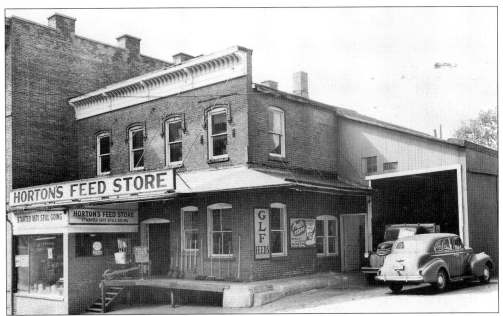

HORTON'S FEED STORE, 1949. Started by Chauncey Horton in 1871 and known as C. S. Horton's and Sons, this Nelson Avenue business is pictured in 1949. Chauncey died in October 1937 at age 90. His son Melvin, well known as a civic and educational leader, remained connected with the family business for 49 years. The old-fashioned feed store was a local landmark until it was razed in the 1960s.

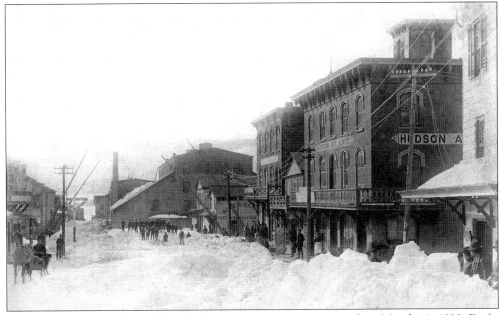

BLIZZARD OF 1888. One of New York's worst snowstorms occurred on March 11, 1888. Drifts created banks between 5 and 15 feet high. The *Highland Democrat* newspaper reported that John Smith Jr. sent out a troop of bareback riders to beat down the snow, followed by a group from Montross stables. John Smith's Hudson Avenue House is seen at the waterfront in this photograph.

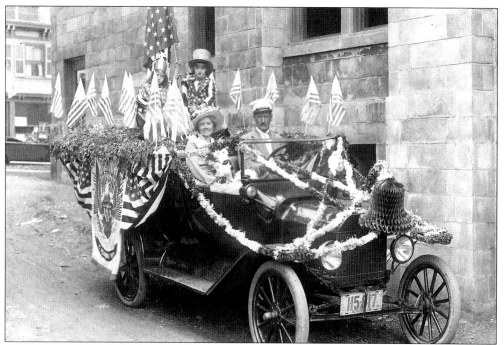

PATRIOTIC DISPLAY. Decorated with a flag and bunting, this car is parked alongside the old police station about 1920. A Fourth of July celebration, huge fire company anniversary, or Memorial Day ceremony likely prompted this motorized display of imaginative red, white, and blue.

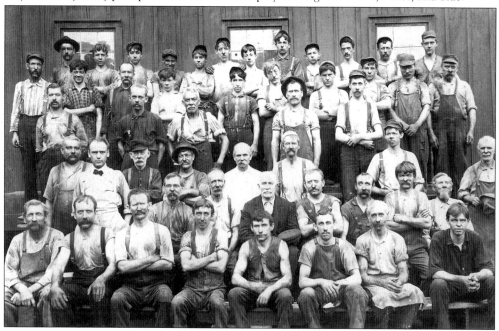

FOUNDRY WORKERS. These 50 workers are pictured in front of the Southard-Robertson stove factory on Main Street, one of Peekskill's most productive and successful foundries. The man folding his arms in the first row, fourth from the left, is Peekskill's famous early bicycle racer Philip Vogt, a member of the Peekskill Wheelmen.

GRIFFIN AND LENT. This drugstore and soda fountain occupied the sidewalk storefront at 938 South Street from 1871 to 1915. The offices of lawyers Stephen Lent and Dwight Herrick benefitted from a second-floor balcony. Herrick's residence was just up the street at 124 Union Avenue, now home to the Peekskill Museum.

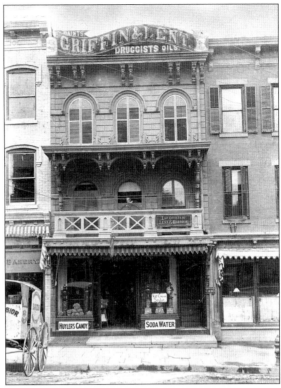

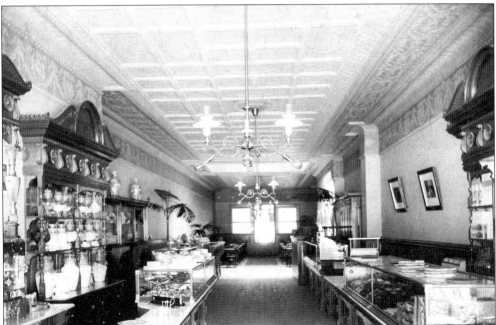

SOUTH STREET SWEETS. The Paul Wessells and Sons bakery and confectionery business of Manser and Wessells began in 1869 by baker William Manser and Paul Wessells, whose first business was manufacturing soda and mineral water. Wessells's sons Frank and Eugene later joined as partners in this ice-cream parlor and soda fountain on South Street.

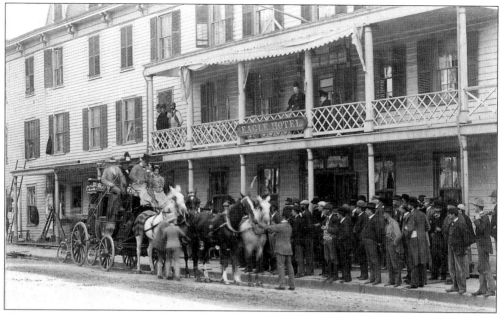

NOTABLES AT EAGLE HOTEL. Members of the wealthy Vanderbilt family arrive in a grand carriage at the Eagle Hotel on October 2, 1895. In the party were the 9th Duke of Marlborough (Charles Richard John Spencer-Churchill), Consuelo Vanderbilt, Alva Erskine Smith Vanderbilt, Colonel and Lucy Jay, and Oliver Hazard Perry Belmont. The Eagle Hotel was located at 1009–1019 Main Street.

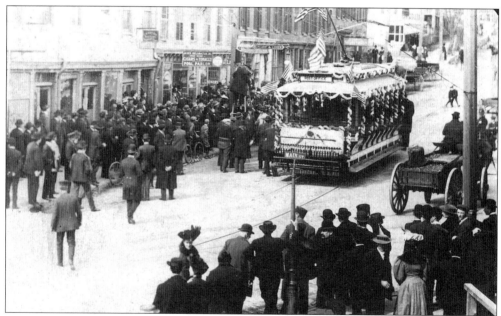

TROLLEY, 1907. "After many years of patient waiting and happy anticipation, the trolley railroad to the Peekskill Hat Manufacturing Company's plant on Division Street is completed," stated Peekskill's *Highland Democrat* on March 23, 1907. In the background of this view are the shops of tobacconist James Delamater Jr. (at 112 North Division Street) and Perry and Loder, selling choice meats, poultry, fish, vegetables, and canned goods.

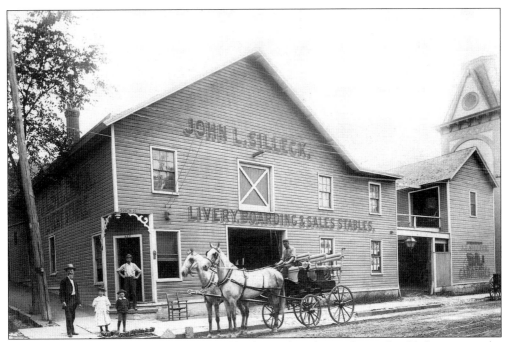

SILLECK STABLES. John L. Silleck operated his livery, boarding, sales, and stable business at the southwest corner of South Street and Union Avenue until 1905. The 1885 Peekskill Directory featured a prominent advertisement for Silleck that offered wagons, buggies, and sleighs from companies such as the Cortland Wagon Company, Boston Buckboard Company, Orville H. Short of Syracuse, and Auburn Farm Wagons.

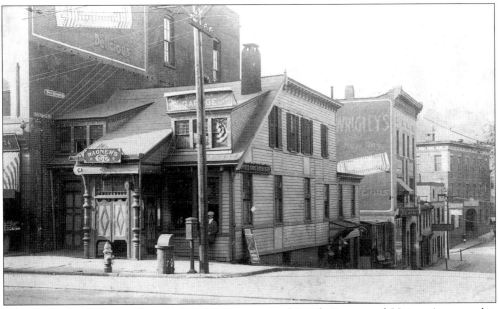

WAGNER'S CAFÉ. Located at the northwest corner of South Street and Union Avenue, this curious building with swinging front doors was an old-fashioned saloon in 1907. Wagner's Café and the buildings directly behind it down Union and Nelson Avenues no longer stand.

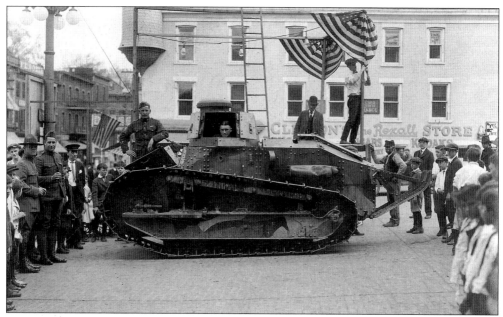

WORLD WAR I TANK. The use of war machinery certainly helped a World War I bond drive in Peekskill that raised a total of $4,586,400. These drives would support the war effort by supplying funds for clothing, food, ammunition, arms, and transportation. In the background is the exterior of the Clinton Drug Company, known as the "Rexall Store," at 1 North Division Street, owned by William H. Clinton.

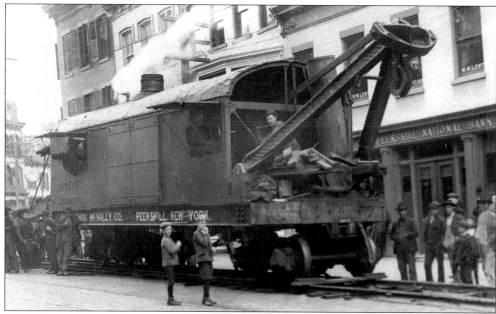

CONSTRUCTION EQUIPMENT ON SOUTH DIVISION STREET. The Thomas McNally Company, general contractors located at 10 Union Avenue, used this early steam shovel for work on the new Croton Dam, completed in 1906. The vast Croton watershed was engineered to provide a reliable water supply to New York City. The Peekskill National Bank can be seen in the background, along with the second-floor offices of optician Wallace W. Lent.

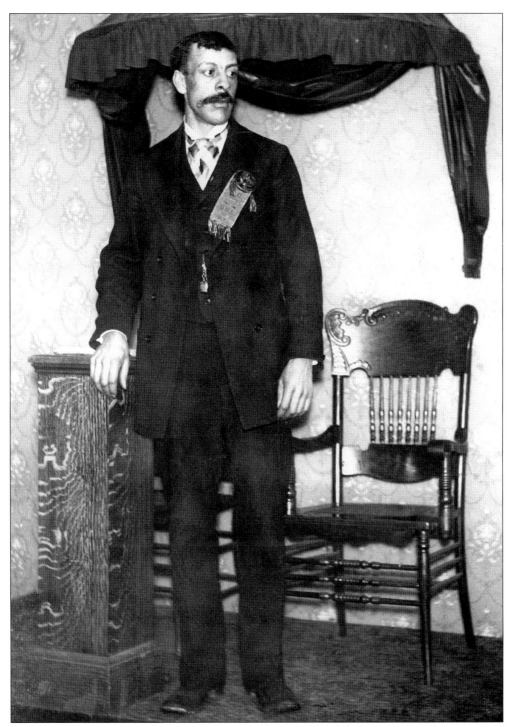

HENRY MOSHIER. A well-known African American of Peekskill, Henry Moshier operated a catering business for 21 years and owned the Savoy Restaurant at 937 Main Street. He died on June 28, 1912, at age 48. The Moshier family's presence in Peekskill dates back to Revolutionary War days.

FRANKLIN AND CLIFFORD COUCH. Franklin Couch, seated at his desk in this undated photograph, was a major writer of Peekskill and Cortlandt local history and genealogy. An attorney since 1875, he practiced law with Calvin Frost in Peekskill. His family history records, donated to the Field Library by his son Clifford (most likely seen to Franklin's left), have been an important genealogical resource for researchers.

PEEKSKILL RIFLE CLUB. Meeting at the Dunderberg Club at nearby Lake Oscawana in 1894 were the following, from left to right: (sitting) Ed Manser, Ed Halsey, Will Crawford, Ed Hodgkins, unidentified, John Snowden, Emmet Sarles, Abe Light, and Asbury Barker; (standing) Doc Fuller, George Durrin, Warren Jordan, Bob MacKellar, Dr. Stephen Horton, "Uncle" Jim Gregory, and Will Smith. The boy in the left rear is Malcolm Lent. Bill Borden and Bill Lent appear in the right window.

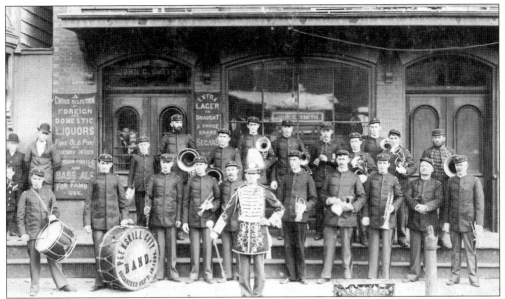

PEEKSKILL CITY BAND. The Peekskill City Band poses in front of John G. Smith's bar at the Hudson Avenue House in 1894. Since Peekskill did not officially become a city until 1940, it is curious that this hometown band took such a name while Peekskill was still a village. Smith was a stove mounter for National Stove Works and a Centennial Hose Company founder. His establishment clearly offered ale, lager, and "segars," among other choices.

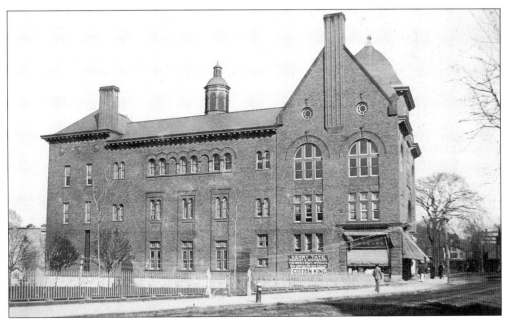

DEPEW OPERA HOUSE. Built as the Peekskill Music Hall at South and Depew Streets in 1890 and renamed in honor of donor Chauncey Depew, this local opera house was a popular entertainment venue for stage performances until its destruction by fire in 1901. Among the acts known to have performed here was John Philip Sousa's Grand Concert Band in 1896, a performance one could see for 25¢, or 50¢ for the first row.

ST. JOSEPH'S HOME. The Missionary Sisters of the Third Order of St. Francis started St. Joseph's Home for dependent boys and girls in 1879. By 1899, it had expanded into a large complex accommodating 1,100 children. The Sisters' goal was the intellectual and vocational education of children, in addition to the personal, spiritual, and physical care they would ordinarily receive from family.

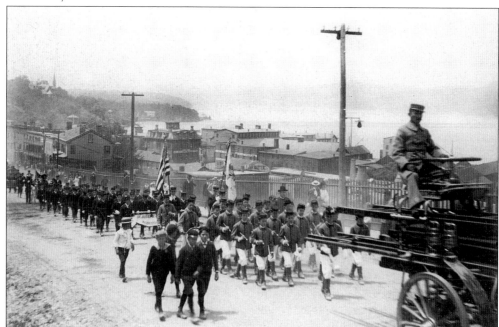

VILLAGE PARADE. Peekskill Military Academy cadets march along Lower South Street with a contingent of boys from the St. Joseph's Home. Partially visible, the hook and ladder truck requires a front and back driver. The busy Peekskill waterfront appears in the background, with New York Stove Works directly in the center of the photograph.

FABRIC STORE. Louis Yudowitz stands outside the Standard Cotton Store at 13 North Division Street as its newly appointed store manager in 1927. After the store's bankruptcy in 1929, Yudowitz assumed ownership and changed the business name to the Cortlandt Cotton Store. Silk, wool, and cotton were clearly the natural fiber materials being offered in the days before most synthetic fabrics were available.

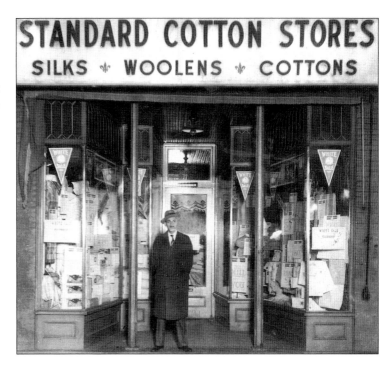

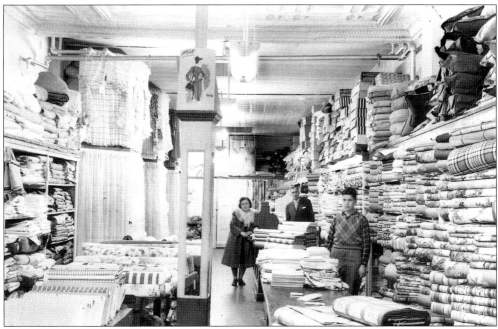

FAMILY BUSINESS. This March 11, 1947, view of the Cortlandt Cotton Store interior reveals the wide varieties of patterns and material available at the shop. Owner Louis Yudowitz is seen with his wife, Mollie, and his son Bernard in the days when a family business was truly a way of life. The photographer was Joseph A. Lillis Jr. of Peekskill.

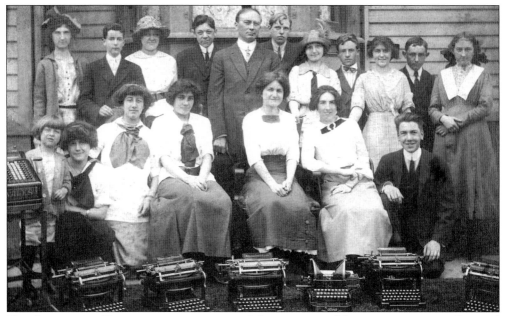

THE INSTITUTE. Typewriters were once vital for commercial business operations. Pictured in this early-20th-century photograph is Joseph Kuhn (standing fifth from the left), one of the principals of the Institute and the Peekskill Shorthand and Business School, located at 177 Union Avenue. Founded in 1869, the institute taught stenography, typewriting, bookkeeping, languages, and music. It became known as the Peekskill Business School after 1935.

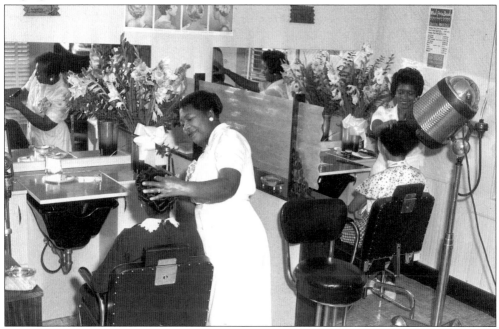

SCOTT BEAUTY SALON. Depicted here in 1958 is the Scott Beauty Salon, a business at 808 Main Street catering to African American clientele. Owner Edith F. Scott (standing at left) appears here with her assistant, Juanita Jackson, using their up-to-date salon equipment. Jackson worked in cosmetology for many years and later operated her own beauty shop on Park Street.

Six

A Private Collection

Frank Goderre has been developing photographic prints from negatives, collecting from available sources, and assembling Peekskill-based archival photographs for many years, with several large binders devoted to one topic. Among his several special interests are scenes featuring automobiles, New York State troopers, and local history. Goderre states the following:

> The photos depicted in this chapter capture my views and special interests of the Peekskill that I grew up to know into the 1970s. It is important to note in the photos the great contribution provided to our community from various emergency operations of the police and fire departments. Generations of local families blended with various immigrant groups made Peekskill what it is today.

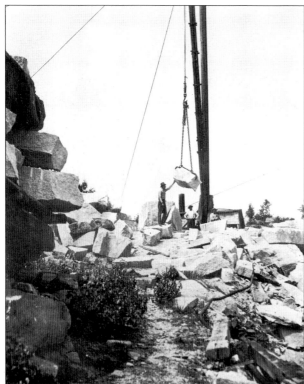

MOHEGAN QUARRIES. Peekskill resident and Italian immigrant Bruno Grenci and his partner, Thomas Ellis, formed the Mohegan Granite Quarries in the early 1900s. Much of the family granite operations moved to Maine in the 1930s.

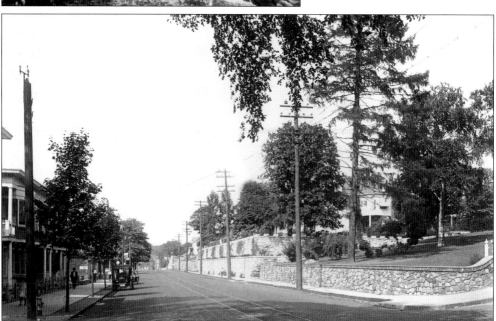

WASHINGTON STREET WALL. The massive granite wall along a west-side block of Washington Street was likely quarried locally. The terraced and crenellated wall remains a remarkable structural edifice. Peekskill trolley tracks are clearly visible in this photograph. Stephen Lent's house appears in the background; it was later purchased as the Baker estate and became the site of Peekskill High School in 1930.

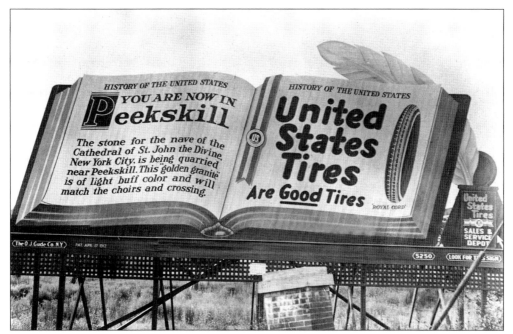

PEEKSKILL, AN OPEN BOOK. This bold sign that stood on Route 202 during the 1920s announced the community's national importance. The left page text revealed that a major architectural structure was being built with special granite cut from an area quarry. Peekskill's Mohegan Granite Company provided stone for the Cathedral of St. John the Divine in New York City with a $5.5 million contract in 1925.

CIVIL WAR MONUMENT. Peekskill and Cortlandt Civil War veterans commissioned this sculpted and inscribed historical monument. Some 58 veterans attended the 1916 dedication ceremony. Of the 665 men from Peekskill and Cortlandt who served, 91 were fatally wounded during military service.

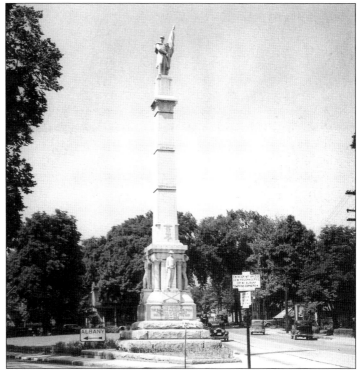

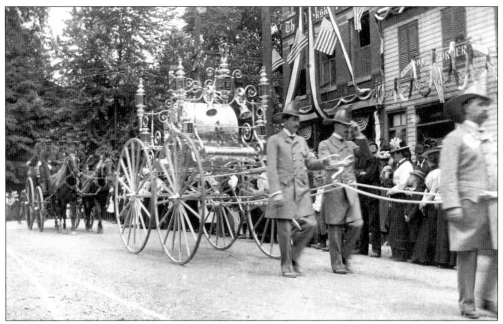

PARADE CARRIAGE. Washington Engine Company No. 2's parade carriage is carefully pulled along South Street in this photograph taken more than a century ago. The *Peekskill Blade* newspaper office was located in the building on the corner of South Division Street, now known as the Riley Building.

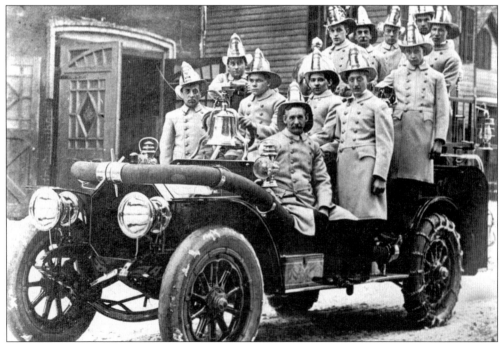

COLUMBIAN ENGINE TRUCK. This Columbian Engine Company truck carried these 12 finely dressed firemen outside the Park Street firehouse in 1909. It was the first motorized fire vehicle purchased by the village of Peekskill.

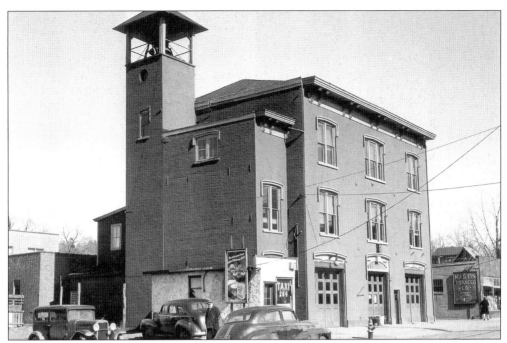

PARK STREET FIREHOUSE. Home to the Columbian Engine, Columbian Hose, and Cortlandt Hook and Ladder Companies, the 1863 building outfitted for fire personnel and trucks was removed in 1965. The bell was relocated to Firemen's Park.

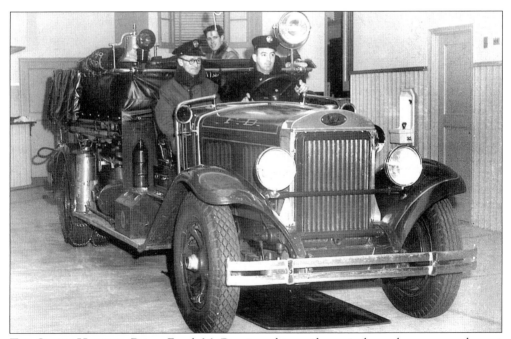

THE GREEN HORNET. Driver Frank McGinnis and two other patrol members are seen here at their new Peekskill Fire Department headquarters on Highland Avenue in 1951. This vehicle, playfully called "the Green Hornet," is still in service with the New York City Police Emergency Services Unit.

OLD DRUM HILL SCHOOL. The 1859 brick Drum Hill School, with a bell tower, was located on the same site as the 1909 building. Drum Hill and Oakside were separate school districts until 1923, when they were consolidated as the Peekskill School District.

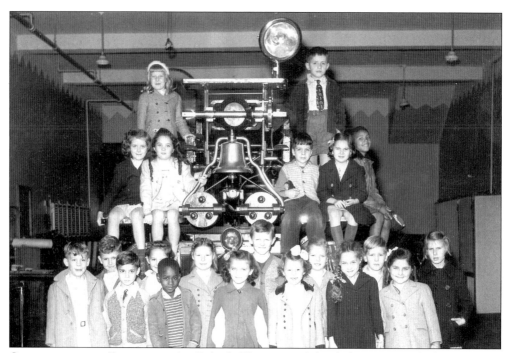

CHILDREN IN THE FIREHOUSE. An Oakside Elementary School class poses with the Cortlandt Hook and Ladder Company truck inside the Main Street firehouse in the 1950s. The truck was a two-man vehicle, called a "tiller."

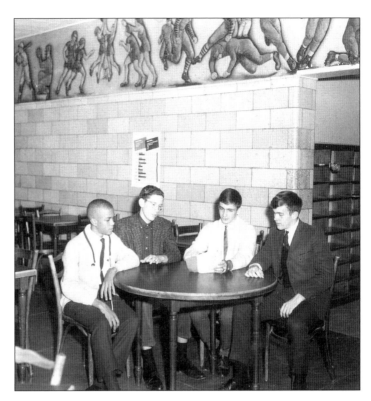

MEETING OF MINDS. Peekskill High School class leaders meet in the Ringgold Street school cafeteria. Gathered beneath the sports mural in 1962 are, from left to right, Steve Rose, George Pataki, Gerard Moretti, and Oscar Scherer.

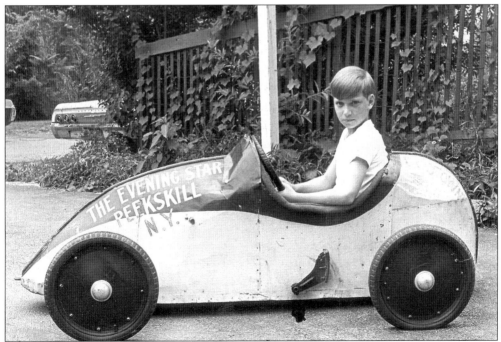

SOAPBOX RACER. Billy Barthelmes sits in the vehicle that his uncle drove when this Dogtown car won the soapbox race in 1936. It was transported to the national derby race at Akron, Ohio, and is now displayed at the Peekskill Museum.

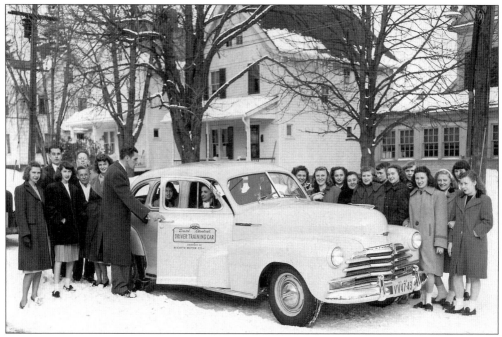

DRIVER TRAINING CAR. The specially equipped dual-control Chevrolet was just the thing for the driver-training class. Here, students surround the car on Ringgold Street in front of the Peekskill High School building in 1947. The vehicle was provided by the Rizzuto Motor Company.

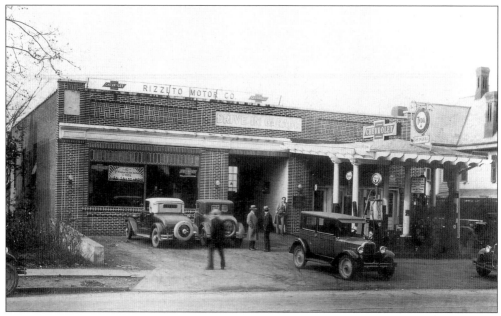

RIZZUTO MOTORS. Chevrolet dealership owner Alec Rizzuto leans against the wall at center in 1928. The show-room gas station was later the location for Peterson Auto Parts for many years.

JOHN BUHS. Peekskill's war hero, Lt. John Buhs, was a flight navigator aboard a World War II heavy bomber. After his plane was hit by enemy fire over Germany in 1944, Buhs suffered permanent paralysis from the parachute drop. Rizzuto Motors, then on Park Street, donated this specially equipped car to Buhs in 1947.

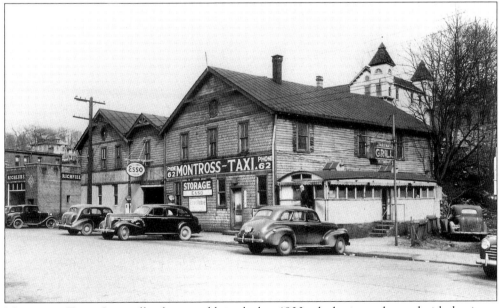

MONTROSS TAXI. Originally a livery stable in the late 1800s, the business changed with the times, becoming the Montross taxi service on Railroad Avenue, as seen in this mid-1940s photograph. The Station Diner was a converted trolley car providing commuters with a convenient lunch.

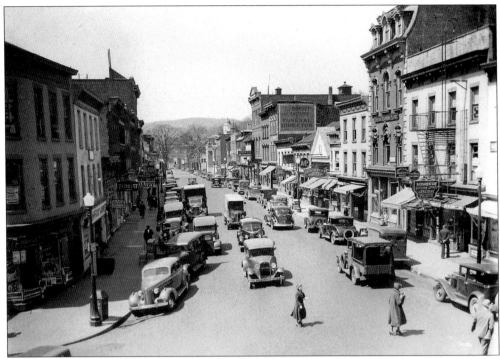

MAIN STREET. Commercial buildings line the north and south sides of Main Street in this 1930s photograph. The A&P seen here was one of four such markets then located in Peekskill.

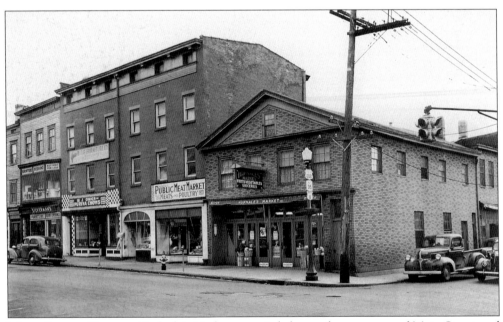

MAIN STREET CORNER. Hufnale's Market occupied the southeast corner of Main Street and Nelson Avenue in 1947. After the Silver Lake business replaced Hufnale's, it experienced a devastating fire in 1968 that affected the connecting buildings. Note Silverman's furniture store just down the block, now located at the Beach Shopping Center.

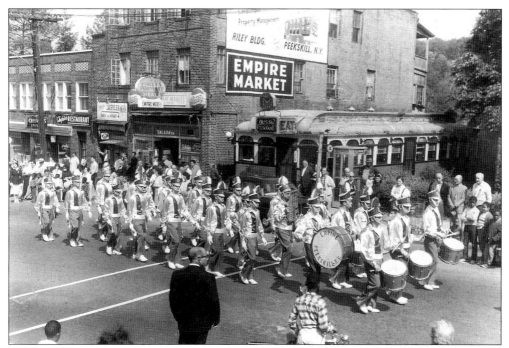

MARCHING ALONG. The flashy Empire Band marches along South Street in the late 1940s. The Miss Peekskill Diner was an old trolley car, revealing a typical reuse of such cars throughout the community.

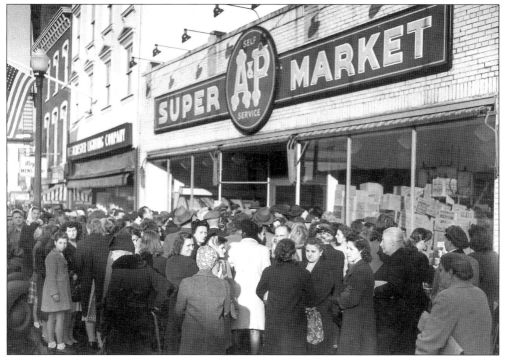

A&P MOBBED. The conclusion of a truckers strike at the A&P market on Main Street, where the Salvation Army is now located, brings out a crowd of local shoppers eager for bargains.

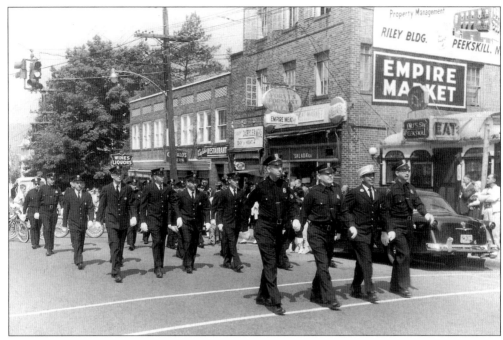

FIRE PATROL MARCHES. The Peekskill fire police parade down South Street in 1954. In the first row, second from the left, is James Lippert, later elected Peekskill fire chief.

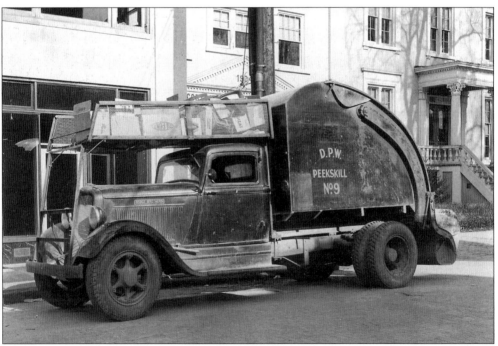

GARBAGE TRUCK. The department of public works' Dodge Brothers garbage truck No. 9 is seen here on Main Street in the 1930s. Note the container above the cab area for trash separation.

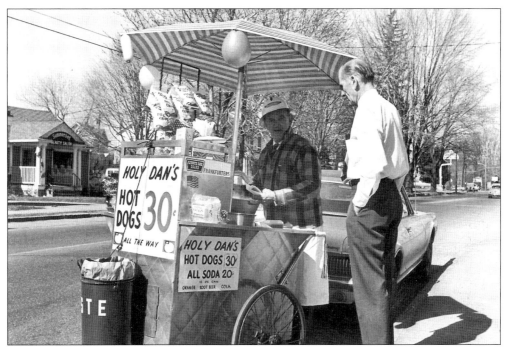

HOT DOG STAND. Dan Sniffen was his own chief cook and waiter at this moveable kitchen stand on Washington Street in 1968. Jack Joyce of the local Sheet Metal Workers Union is the customer in this scene. The location is still popular for this type of vending.

ROAD KNIGHTS. One of the first Road Knights Club car shows was inside the Washington Street Armory. After several years in Verplanck, the show now draws thousands to the Peekskill Riverfront Green Park. Members specialize in restoring American automobiles of the past and displaying their attractive features to the public.

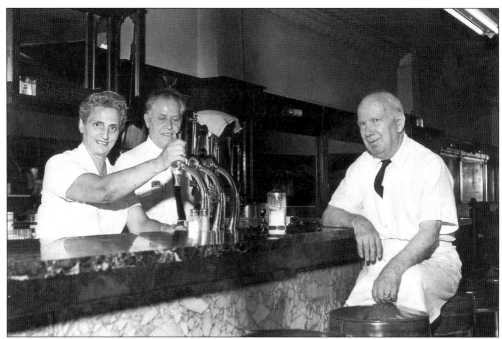

SIOLES RETIRES. After 48 years behind the soda fountain in the Sioles shop on South Street, Bessie (left) and Louis Pappas draw the last soda for William Sioles. This type of business existed well into the 1900s as a reminder of even earlier days in the downtown.

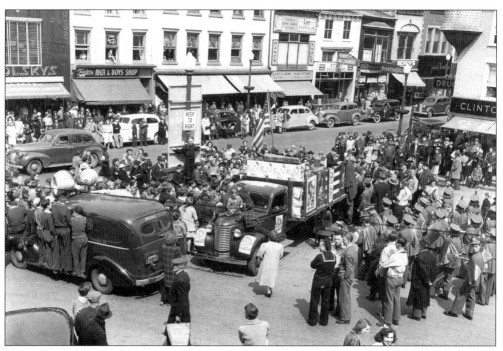

BOND RALLY. A popular means of financing the tremendous efforts of World War II was with the sale of government bonds, similar to the process used during World War I. The Peekskill High School band was present for this rally in April 1943.

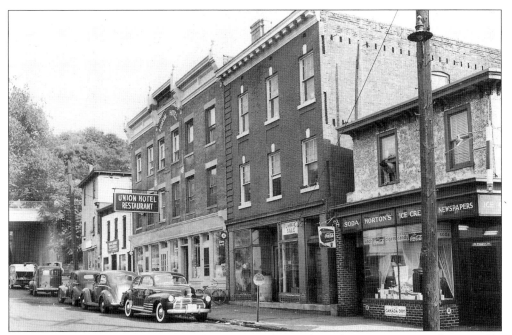

UNION HOTEL. Conveniently located at the waterfront, where the train station and river traffic converged, the Union Hotel is one of the few remaining establishments of its type. John J. Scivoletto was the longtime owner and operator of this business and a fan of the New York Jets team members when in Peekskill.

CHRISTOPHER COLUMBUS HALL. The Christopher Columbus Society has been active in Peekskill since 1901. The Italian social and benevolent organization building was once located at 1115 Main Street and is now situated on Crompond Road.

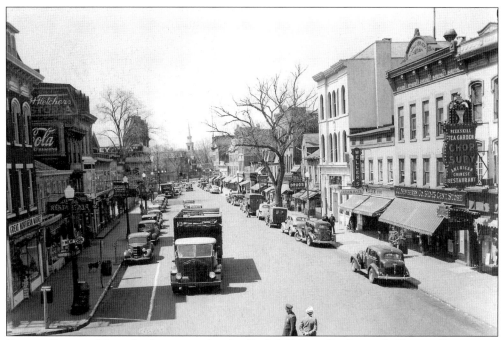

SOUTH STREET. Note the large sign for the Peekskill Tea Garden and Chinese Restaurant hanging on the South Street building on the right. The street was a curious mix in the 1930s, with a church, theater, three-story bank, and a hotel.

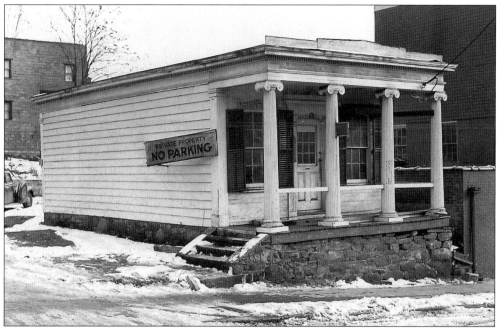

ANTIQUE LAW OFFICE. William Nelson's original law office was located adjacent to his home at the corner of Main Street and Nelson Avenue, where city hall is situated. The 1820s Classical Revival office was relocated across Nelson Avenue, and then to Depew Street near Woodside School. The structure no longer stands.

JOE NAMETH. The popular New York Jets quarterback received national attention for his excellent athletic performance and engaging personality. Nameth made use of this recognition to appear in several television commercials. This photograph was taken at the Peekskill training camp.

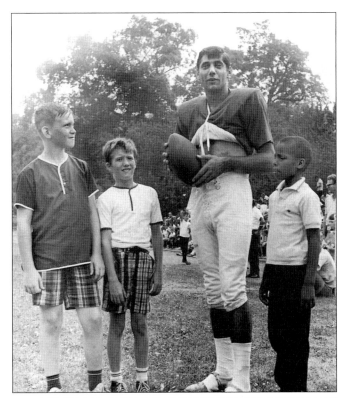

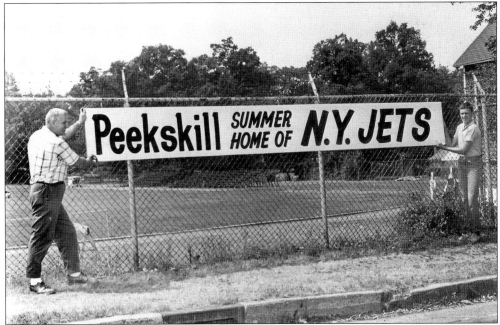

A BANNER TO BEHOLD. Jack Timmons of Signs by Jack and his son hang this banner for the Peekskill Area Chamber of Commerce in 1965. The Peekskill Military Academy's Depew Field, seen here, was where the New York Jets began their summer training. It is now known as Torpy Field.

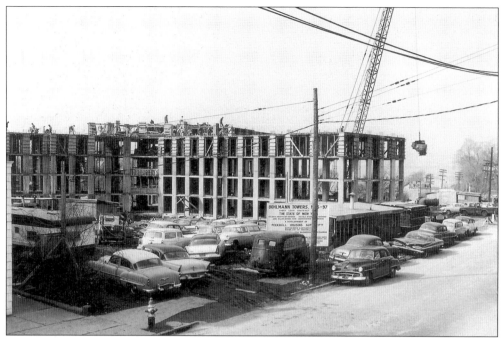

BOHLMANN RISES. Gov. Nelson Rockefeller dedicated Bohlmann Towers in 1961, while praising its "public housing look." Named for a former Peekskill educator, the apartment complex featured 134 units for approximately 600 people.

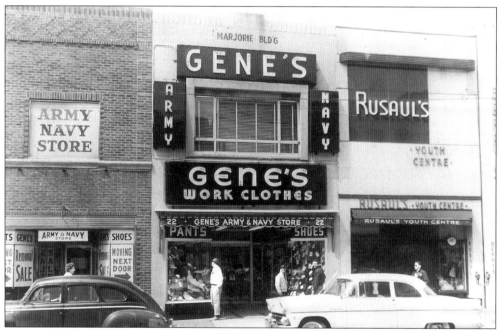

GENE'S. The Ettinger family owned and operated this downtown army and navy business across two storefronts for decades. Its principal offerings were work shoes and clothes. Army and navy surplus items were also offered at discount prices.

LOUIS PATAKI. Father of New York governor George Pataki, Louis worked as the assistant postmaster at the Peekskill Post Office in 1965. Pataki family members also operated a small farm along Frost Lane.

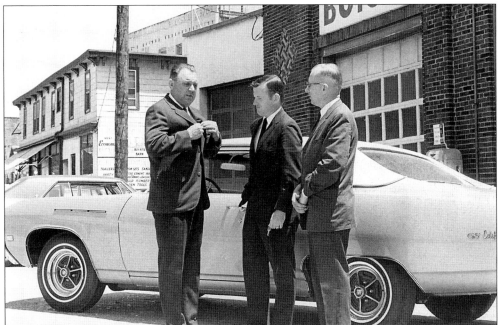

NEW BUICK. Automobile dealerships have a long tradition in Peekskill, with business owner Bill Geis at left in this 1968 scene. Arthur King (center) has just received his keys from division manager Charles Sellers. Geis has since expanded his automotive offerings into foreign and domestic cars.

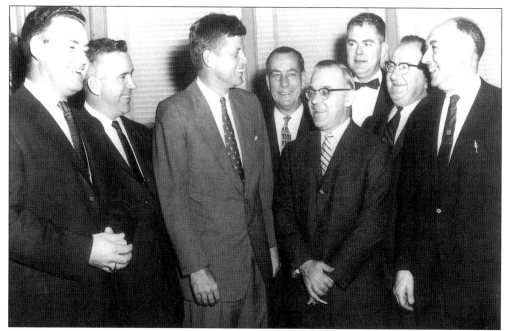

JOHN KENNEDY. Massachusetts senator and future U.S. president John F. Kennedy was warmly received by these Peekskill Democrats in 1959. Pictured here, from left to right, are Jack Cothren, Robert Sterling, Kennedy, Harold Tompkins, Ferdinand Gagliardi, James Lennox, Joe Martin, and Joe Calabrese.

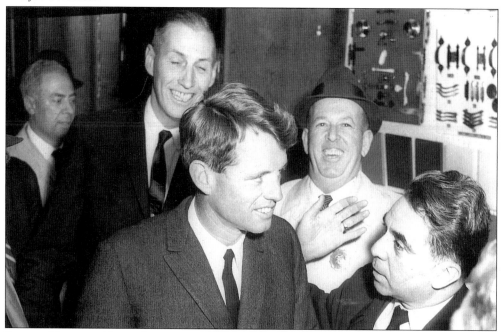

ROBERT KENNEDY. During his transition from U.S. attorney general to New York senator, Robert Kennedy visited Peekskill, where he met with Mayor Gambino (1964–1965), in the bottom right corner. In this scene, former Buchanan mayor William Burke stands directly behind Kennedy, while police lieutenant Leo McCaffrey is behind the senator on the right.

Seven

The Peekskill
Military Academy

The Peekskill Military Academy (PMA) was organized by the community's leading citizens in 1833. The private boarding and day school was considered necessary to provide a quality education for the community's growing families.

By carefully placing the new Peekskill Academy on a Revolutionary War site once important to the Continental army when it was based here in the 1700s, officials ensured its popularity. One modest school building soon led to two. By 1838, the 47 enrolled students were each paying $678 in yearly tuition, a considerable amount for education at that time. The curriculum was typical of the mid-1800s educational philosophy: English, Latin, Greek, French, mathematics, and science.

The school became restricted to boys in 1841. Principal Albert Wells began the Highland Cadet Corps program in 1857. The conversion to a military program was meant to develop qualities of character, discipline, and leadership in students, and perhaps revealed Wells's accurate sense of a foreboding national confrontation.

A century of students enrolled and graduated as the Peekskill Military Academy developed a steadily growing national and international reputation for educational excellence. The path was not always an easy one, as two devastating fires caused considerable damage to academy buildings in 1886 and 1909. The academy was helped by a few benefactors. Peekskill's famous orator, U.S. senator, railroad president, and PMA graduate (class of 1852) Chauncey Depew was generous to his former school. Graduate James B. Ford (class of 1863), vice-president of the U.S. Rubber Corporation, sponsored several significant building projects, including the magnificently designed multi-purpose administration building in the early 1900s.

Quality education was evident in the 100 percent college acceptance rates for PMA graduates, as enrollment expanded to 350 cadets in the 1950s. The platform of academic college preparation in a military environment encouraged many graduates to pursue distinguished military careers in all branches of service. The Peekskill Military Academy was forced to close in 1968.

The complex once consisted of 17 buildings on 53 prime acres of Oakhill overlooking the Hudson River. The "hanging tree," where military rules were enforced by American troops in 1777, remained an enduring reminder that courage and pain were necessary for the United States of America to be realized. Part of the former campus is now the site of the Peekskill High School. As the years go on, the PMA Alumni Association keeps alive the memories and values of that venerable institution, active in Peekskill for 135 years.

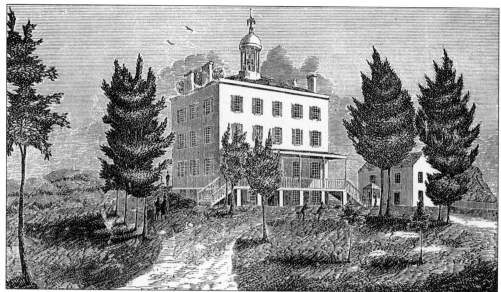

THE FIRST BUILDING. This is a rendering of the original academy building, as it appeared in 1834 at a total cost of $5,127.23. It was 50 feet long and 36 feet wide and three stories high with a full basement. It included five fireplaces, dormitories, a full kitchen, a laundry, and living accommodations for the principal and his family. Unfortunately, the building was totally destroyed in the fire of 1886.

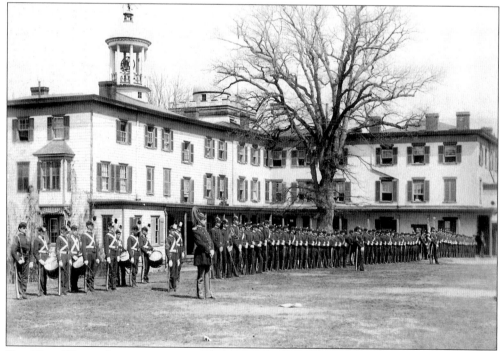

THE NEW WING. A new wing was added to the main academy building to accommodate its expanding enrollment and academic program. In this 1890 photograph, the cadet corps is in formation in front of the building, with the historic old oak tree in the background.

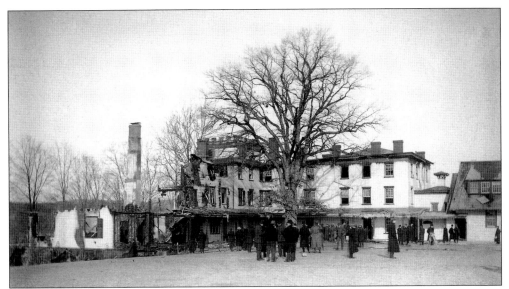

Second Fire. This photograph was taken on January 13, 1908, the day after the second major PMA fire. Despite the obvious devastation, the cadets only missed four days of school. Classes were temporarily transferred to the Guardian Building, which had recently been built by the Church of the Assumption. Students were housed in neighborhood family homes.

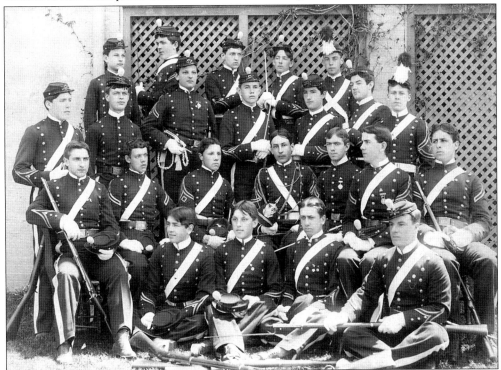

Company A. The cadets in this 1892 image demonstrate careful attention to detail. Punctuality, respect, and personal appearance were stressed and became part of the program to produce well-rounded young adults. A rigorous academic schedule qualified graduates for admission into the nation's finest colleges or careers in the military, business, or professional venues.

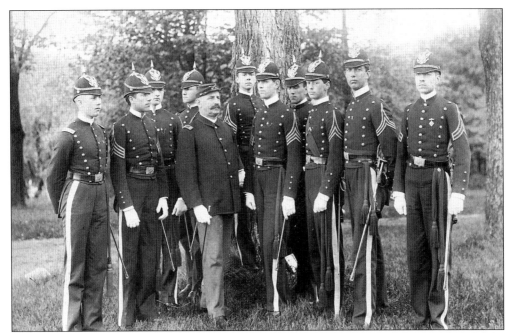

THE COMMANDANT. Col. Lewis Orleman, Ph.D., served as principal and commandant of the Peekskill Military Academy from 1894 to 1903. Here, he is seen with the senior cadet officers of the battalion. The school's reputation spread worldwide, and enrollment grew at a steady pace that required expansion of the campus.

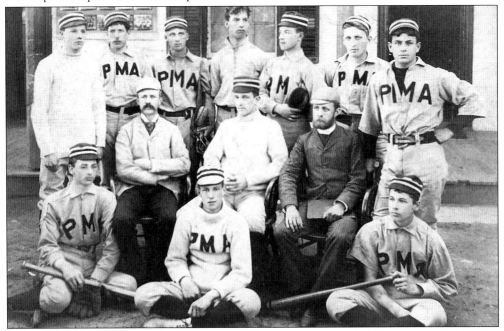

BASEBALL, 1890. Physical activity was also a key part of a cadet's life, as evidenced by this image of a baseball team. Intramural and varsity athletics were included in the daily schedule, and all students were required to participate. A winning spirit and the value of teamwork and competition would serve the young men well in their future lives.

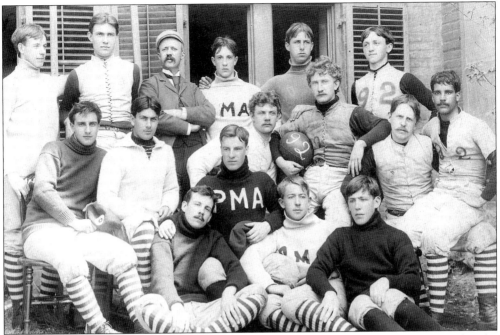

Rugby, 1892. PMA emphasized athletics in developing character and physical strength. The striped leggings of these rough rugby players made recognizing teams members easier while simultaneously dazzling opponents.

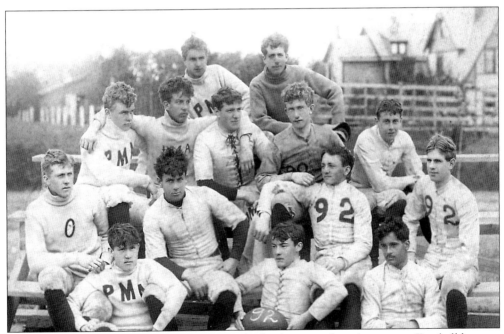

Football, 1892. There is not a helmet in sight for this rugged academy team. Football became an American favorite as a team sport. Constant action and strong school rivalries were a means of encountering competition within a sports context.

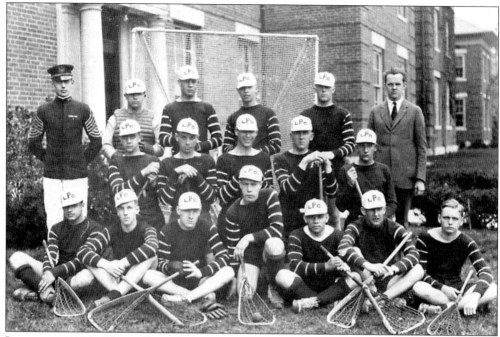

LACROSSE, 1923. The well-rounded sports curriculum at PMA included lacrosse, which for a time became its most popular offering. The team shown here traveled far and wide to find competition in those early years. Opponents were Princeton, Yale, Alexander Hamilton High School, the New York Military Academy, the Plebes from West Point and Annapolis, and the students from the Manual Training High School at Indian Point.

WHERE'S THE BALL? Lacrosse was thriving in 1947 and continued to be a popular sport through 1968 when the school closed. The swimming program was introduced in 1927 with the construction of the administration building, which included a 20-yard heated pool. That pool still holds international records in its class and produced many swimmers that went on to become collegiate and Olympic medal winners.

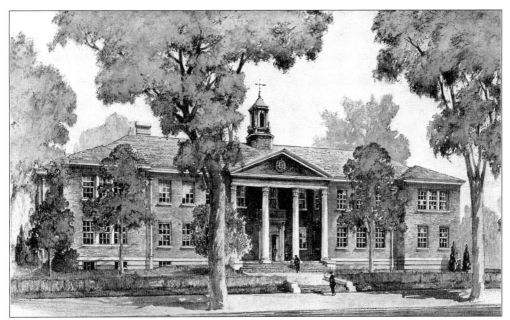

ADMINISTRATION BUILDING. Completed in 1927, largely through the generous contribution of James B. Ford (class of 1863), this is the only remaining structure from the original campus. In addition to its heated swimming pool, the building contained a gymnasium, a 500-seat auditorium with a magnificent 32-rank Austin pipe organ, a rifle range, 10 classrooms and laboratories, and the school administrative offices.

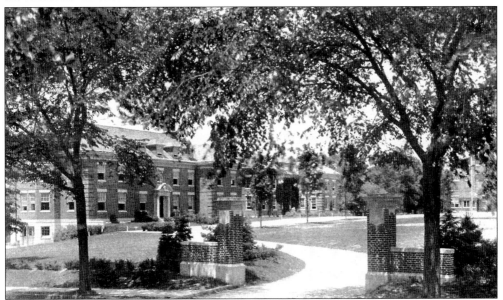

MAIN GATEWAY. The campus entrance was on Elm Street, directly across from the administration building. On the left in this view is the Ford Upper Manor House, containing student and faculty living quarters, recreational rooms, the store, canteen, tailor, barbershop, and student post office. Beside it, the alumni building housed the Junior School. The far right building was called the "Old Main," with living quarters, classrooms, the school museum, and various student and faculty offices.

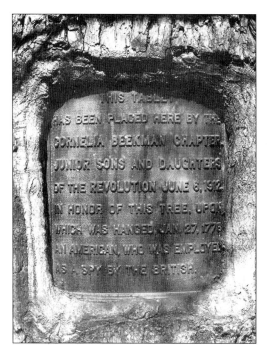

THE OLD OAK. The existing tree was the scene of a drumhead court martial and subsequent hanging of Daniel Strang in January 1777. Continental soldiers camping on the site observed Strang reconnoitering the area and making notes of troop movements for British forces. This tablet, placed on the tree in 1912, is accurate to the place but the year is misstated.

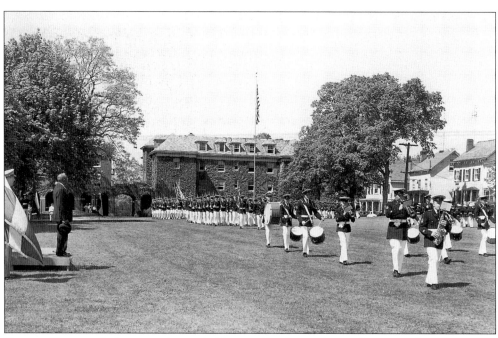

PASS IN REVIEW. A dress parade was held every Sunday at the academy, weather permitting. This was an opportunity for parents and friends to visit the campus. The sound of military music would also attract a contingent of local residents. International and prominent public figures often attended these parades. The dormitory building in the background was known as "The 26," as it was completed in 1926.

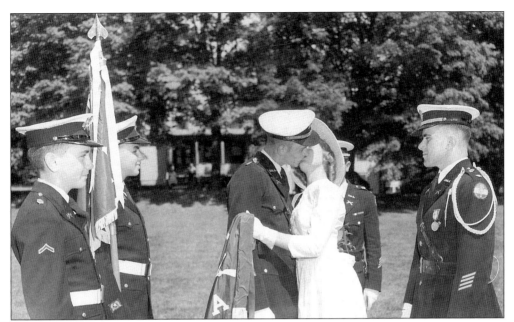

COLOR GIRL CEREMONY. In addition to frequent proms and dances, the corps would dedicate a Sunday parade to the Color Girl Ceremony. A competition would be held to judge the best marching unit in the parade. The company commander of that unit would then be awarded a ribbon to display on the company guidon (flag). Here, the commander of A Company receives the ribbon and a kiss from his favorite girl in 1946.

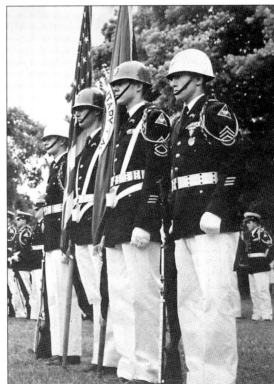

COLOR GUARD. Cadet uniforms were generally patterned after U.S. Army uniforms of its era. Starting with the Civil War, PMA adopted a blue and gray dress uniform. The 1920s saw a dark blue or black tunic with matching dark pants during the winter months, and white ducks in warmer months. The Color Guard, shown here in 1959, wears the typical uniform.

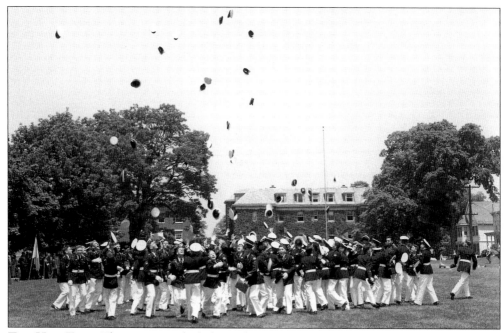

THE HAT TOSS. This event marked the end of the 1956 academic year. After the hat toss, seniors locked arms and formed a circle. The underclassmen then charged the circle and tried to break through. Tradition says the circle would never be broken. Following this final parade of the year, the cadets dispersed to return home for the summer.

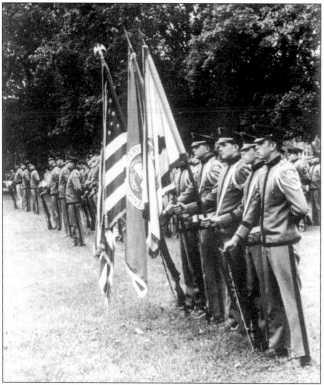

THE 1960s. Declining enrollment, fueled by the anti-military sentiment surrounding the Vietnam War, caused a financial crisis that could not be resolved. After 135 years of providing an outstanding, well-rounded education for thousands of young men, the Peekskill Military Academy was forced to end its operations in 1968. This photograph was taken at one of the last Sunday parades.

Eight

THE POLICE DEPARTMENT

Peekskill's independent police department began in 1849 with the appointment of Leonard Smith as village constable. In addition to his policing duties, Constable Smith would light the evening gas lamps and as the pound master be responsible for loose cows, horses, sheep, chickens, and dogs. The first village lockup was a 12-by-20-foot brick cell on Nelson Avenue supervised by jailor John Sloat in 1854. Its walls were 10 feet high and 12 inches thick.

Local law enforcement became organized in 1888 with specifications for dark blue uniforms similar to those used by New York City officers. Patrolmen were to wear shields on their caps and coats, to carry wooden clubs, and to work specified shifts. Peekskill police officers were to act and appear as professional workers, as outlined in a 1902 rules and regulations manual. Patrolmen were to be ever-watchful, careful in their own behavior, dedicated to their work, and sober. The manual also specified white gloves to be worn in summer and dark gloves in winter.

With the purchase of a single motorcycle in 1910, the Peekskill Police Department entered the modern age.

As the village population and the number of factory workers expanded in the early 1900s, along with the proliferation of taverns and saloons before Prohibition, it was deemed beneficial to establish an expanded and conspicuous police headquarters on Central Avenue in 1914. That building was replaced by the current Nelson Avenue station in 1969.

Policing became a controlled profession with qualifications required by civil service lists starting in 1913. A modernized police department was organized by 1940 with a 25-member workforce including a chief, lieutenant, 2 sergeants, and 23 patrolmen. The combination of patrol cars, motorcycles, foot patrolmen, and corner call boxes was a significant step in the department's formation. By 1990, the department had increased to 51 personnel. The police force of 2005 consists of 77 sworn officers and civilian support personnel. The contemporary police officer not only enforces written laws, but often acts as a social worker, marriage counselor, or first-aid giver in crisis situations.

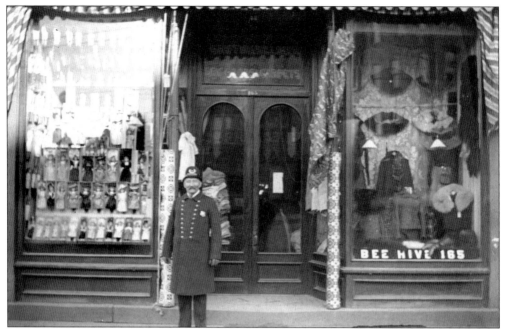

WINTER PATROLMAN. In his fine overcoat and round cap, an unidentified Peekskill patrolman stands in front of the Griffin and Hilliker dry goods store in the late 1800s. Note the extensive doll varieties in the left store window and the fashionable ladies winter wear to the right. This photograph represents the transition from the 1800s to the 1900s.

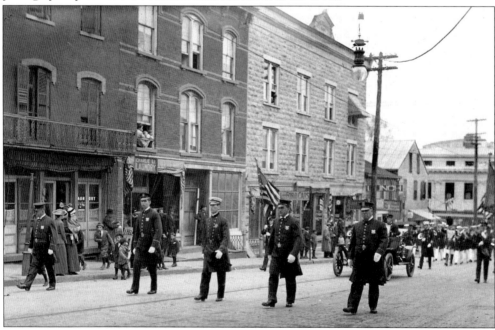

PARADING ON YELLOW BRICK. A police force contingent leads a parade along a distinctive Peekskill road of yellow brick, with its inset electric trolley tracks, on North Division Street just past Main Street. Included in this picture are patrolmen John Crawford, Joseph Lillis, John Shea, and Chief Henry Burke, appointed in 1918, wearing the white cap at center.

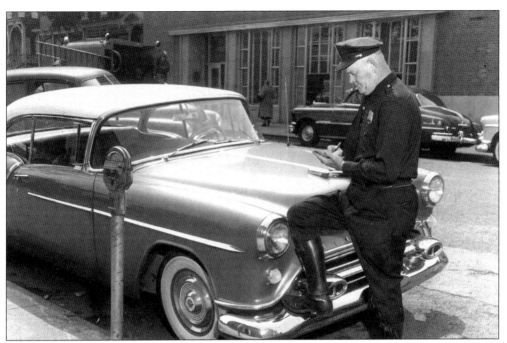

WRITING A TICKET. Patrolman Arthur Frost tickets an attractive Oldsmobile on a downtown street for a parking meter violation in 1957. Then as now, such incidents are not uncommon.

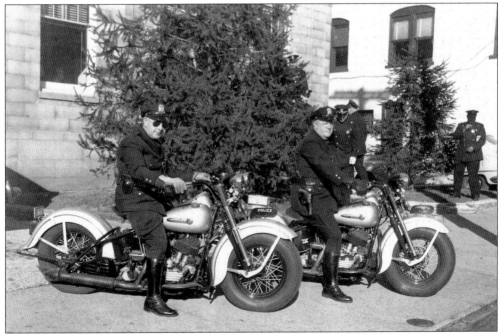

TWO MOTORCYCLES. A pair of powerful Harley-Davidson motorcycles were outfitted as police vehicles in the 1950s. The two motorcycle cops were also well outfitted, in leather gloves and fine boots. The vehicles were excellent for weaving in and out of traffic.

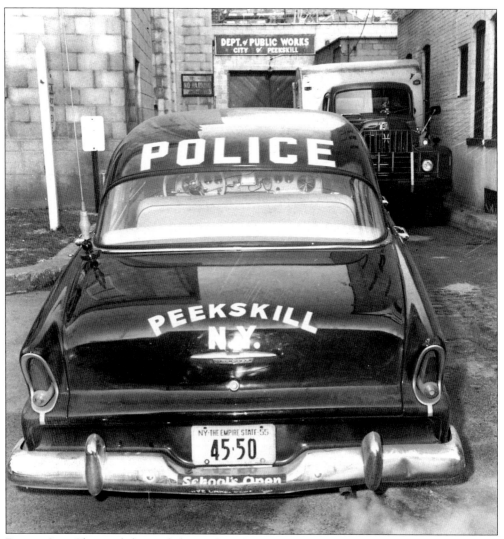

POLICE CAR. The neatly lettered Plymouth parked alongside the old police headquarters building on Central Avenue in 1956 was part of the department's motorized support. Note also the use of the rear garage by the department of public works.

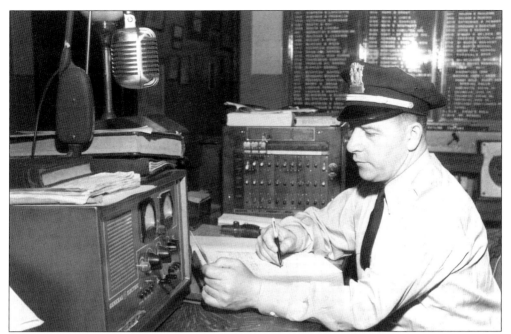

CALLING ALL CARS. Lt. Albert Vitolo is inside headquarters in 1957, surrounded by the latest in General Electric communications technology. Behind him is a list of fire alarm box numbers and locations. The Peekskill Police Department has always been able to keep pace with the newest support technologies.

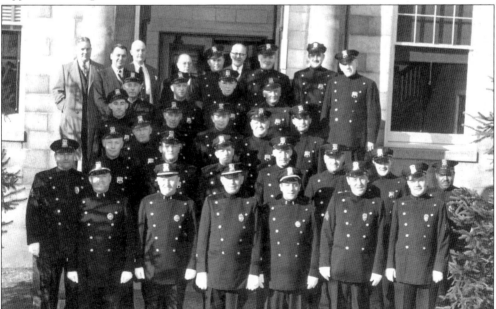

PORTRAIT, 1951. Most of Peekskill's police force appears here in front of headquarters on Central Avenue. Also present are several politicians standing in the back. They are Francis Phalen, Ted DeChristopher, Bartholomew Moynahan, Harold Mabie, and Mayor Charles Doyle. Charles Bolden, second row on the right, was the first local African American police officer. Peter King, the chief at the time, is seen in the center of the front row.

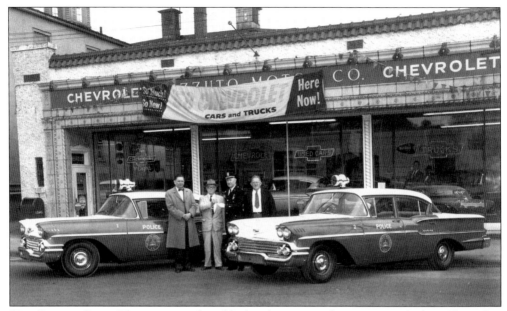

NEW PATROL CARS. The transition from black police cars to these green-and-white Chevrolets indicates the department's efforts to keep pace with the times in the 1950s. Alex Rizzuto is seen here with councilman Vincent Panniteri, Lt. Peter King, and councilman Foster Banker.

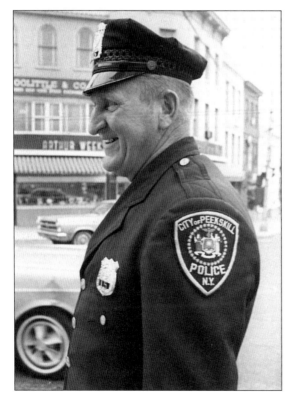

NEW PATCH. Patrolman Harry Rice proudly wears the newly issued "City of Peekskill Police" uniform patch in 1970. The daily opportunities and challenges that local police encounter during their work are approached with personal confidence, departmental pride, and professional skills that affirm positive civic values.

Nine

NEARBY PEEKSKILL

Through more than a century, the distinct communities of Peekskill and Cortlandt have been like brother and sister, related within the same family but quite individualistic. This is why a "Nearby Peekskill" chapter is important to understanding the historical context.

Peekskill has been a particular political and financial trendsetter to the county and surrounding area for most of its existence. The nearby communities of Cortlandt, Putnam Valley, and Yorktown originally saw Peekskill as their commercial, occupational, and social heart. For residents of Annsville, Van Cortlandtville, Shrub Oak, Mohegan Lake, Jefferson Valley, Garrison, Croton, Buchanan, Montrose, and Verplanck, Peekskill became their primary place for entertainment at its several theaters and the opera house. Peekskill was the place to do business, shop, seek legal and medical attention, and participate in the Rotary, Elks, Moose, Hibernians, Masons, and Oddfellows organizations.

Peekskill newspapers were the publications most often read from Cold Spring to Ossining, Cortlandt to Yorktown. Its several private schools offered specialized educational opportunities. Peekskill Hospital served all the surrounding areas with its facilities, doctors, and nurses.

The traffic often went both ways, with many Peekskill residents working at the Montrose Veterans' Hospital, at the Indian Point nuclear power plant, or years ago at the wooded middle-class resort created by Valeria Langeloth on Furnace Dock Road. Valeria's 550 acres accommodated a maximum of 200 guests at a time from 1924 to 1973.

Sport and professional fishing were once significant activities, as shad nets were spread out in the bay and shore areas of Cortlandt. Sturgeon, blue crab, and shad were captured in quantities that offered distinctive taste experiences and occasional supplements to the daily table. And while the Hudson River Day liners did not reach Peekskill docks, the large pleasure boats enjoyed an active trade at Indian Point and Bear Mountain, and were well attended by locals and those on excursions. Thus, Peekskill was often correctly described as "the Gateway to the Highlands."

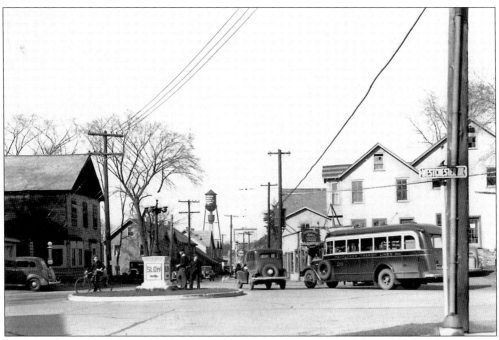

ROUND AND ROUND. The Buchanan traffic circle is pictured here in April 1947. Westchester, Tate, and Lindsey Avenues and White Street are some of the road choices from this roundabout. The Standard Coated Textile Wallpaper Products water tank appears in the center distance.

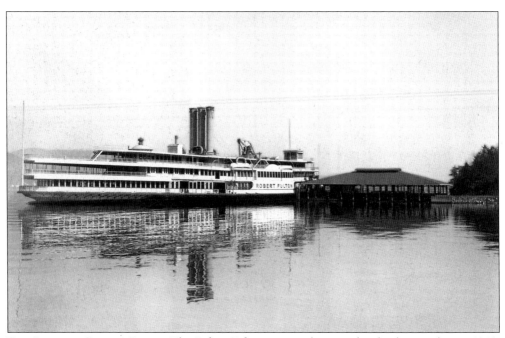

DAY LINER AT INDIAN POINT. The *Robert Fulton* was an elegant side-wheel steamship in 1940, when the Hudson River Day Line Company owned Indian Point Amusement Park in Buchanan. This excursion boat, built in New Jersey with a steel hull, was active from 1909 to 1954.

JUMPING HIGH. Masterful ski jumpers once participated in this high-flying winter sport at the Bear Mountain ski-jump platform, located next to the lodge, as seen in January 1945. Some of the world's best jumpers participated in these events amid Hudson Valley winter scenery.

ROUND 'EM UP. Cimarron Ranch in Putnam Valley was a tourist spot for old-time rodeos and equestrian shows, as evidenced by the 50 horses and riders assembled inside the corral. Those who loved horses and reminders of the Old West made this locale a popular summer spot.

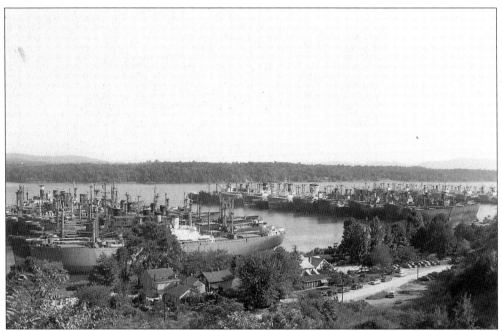

NAVAL RESERVE FLEET. Jones Point was one of nine national sites where retired World War II Liberty ships were anchored in 1954. The large gray transports were a constant sight on the Hudson River from 1945 to 1971. Each named for a notable American, they carried troops, oil, and various cargoes around the world for military purposes.

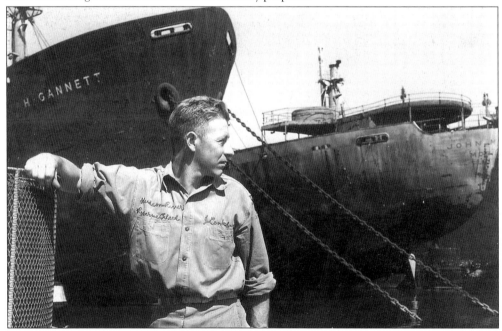

GHOST FLEET CREWMAN. J. Conklin is pictured here beneath the bow of the *H. Gannett*. The Liberty ships required constant maintenance so they could be reactivated, moved, or sold. The Hudson River was temporary home to 189 retired World War II transport vessels. The Korean and Vietnam Wars then drew upon this naval reserve fleet in the 1950s and 1960s.

ANNSVILLE FISHERMAN. William Wiand fills up his rowboat at the original Peek's Creek in May 1959. In the mid-1700s, Caleb Hall started Peekskill's first commercial dock on this shore, always a popular spot for fishing and crabbing.

INDIAN POINT. The motorboat *Miss Indian Point V* provided tours of the numerous moth-balled World War II transports seen in the background of this July 1952 photograph. Indian Point Amusement Park in Buchanan offered this excursion before the Consolidated Edison Company acquired the property for its nuclear power stations.

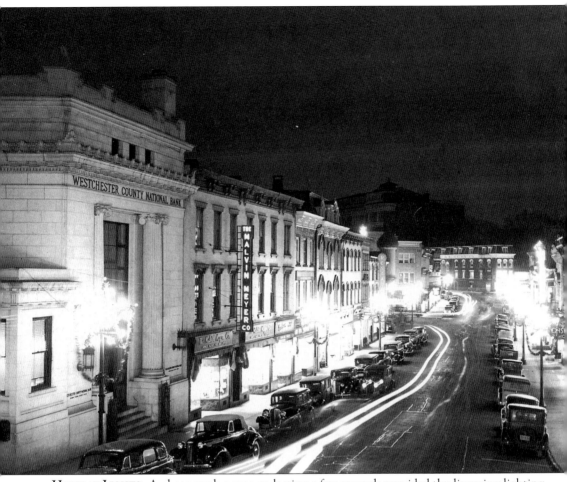

HOLIDAY LIGHTS. A photograph exposure lasting a few seconds provided the lingering lighting effects in this appealing night scene on Division Street in December 1947. Peekskill's allure is well preserved in this and so many other images.